Glass:

Material
in the service of
Meaning

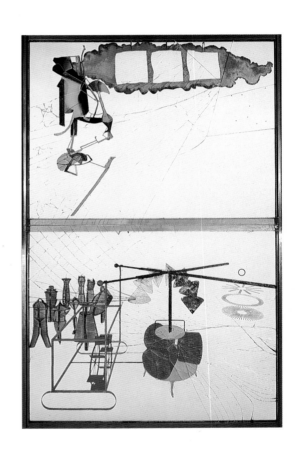

Glass:

Material
in the service of
Meaning

Introduction by

Ginny Ruffner

Essays by

Ron Glowen

and Kim Levin

Tacoma Art Museum

in association with the

University of Washington Press

Seattle & London

Glass: Material in the Service of Meaning is published in conjunction with an exhibition organized by the Tacoma Art Museum, Tacoma, Washington, November 2, 1991, to January 26, 1992.

Exhibition curator: Ginny Ruffner

Frontispiece:
Marcel Duchamp (American, 1887–1968)
The Bride Stripped Bare by Her Bachelors, Even
or *The Large Glass* (1915–1923)
Oil and lead wire on glass
109 1/4 x 69 1/8 in.
Philadelphia Museum of Art, Bequest of Katherine S. Dreier
Reproduced with permission

Catalogue designer: Katy Homans
Editor: Lorna Price
Catalogue coordinator: Barbara Johns

Photo credits:
Nicholas Whitman, p. 27; Richard Nicol, pp. 31, 37 (top), 39, 51;
Galerie Yvon Lambert, p. 41 ; Dennis Crowley, p. 43;
Mike Seidl, p. 47; Colleen Chartier, p. 55 (inset)

Distributed by the University of Washington Press
P. O. Box 50096
Seattle, WA 98145

Printed in Hong Kong

Table of Contents

Acknowledgments

In an exhibition of this scope, there are always many people to thank, many people who believed and acted, many people whose hard work make this idea a reality. This seems especially true of *Glass: Material in the Service of Meaning.*

A great deal of credit for the existence of this exhibition must be given to Wendell Ott, director of the Tacoma Art Museum, who from the beginning of this project consistently supported it, as did the Board of Trustees. Thanks also to Barbara Johns, curator of exhibitions, the in-house guiding light, as well as Jim McDonald, Mary Clure, Greg Bell, and Laura Thayer at the Tacoma Art Museum for their creativity, professionalism, good humor, and diligence.

Making this catalogue was another project equal in scope to the exhibition. For its beauty and execution, accolades go to book designer Katy Homans; for its content, thanks to authors Ron Glowen and Kim Levin; for its lucidity, thanks to editor Lorna Price.

Finally, I'd like to thank the artists for having the courage to make art and the graciousness to exhibit it.

Ginny Ruffner
Seattle, June 1991

Foreword

The Tacoma Art Museum is pleased to sponsor this exhibition of works by American artists who are using glass in innovative ways. Numerous exhibitions of glass as an artist's medium have been organized in the Northwest, recognizing work done directly and indirectly as a result of the presence of Dale Chihuly and the Pilchuck Glass School in Stanwood, Washington. Chihuly's work evolves out of the tradition of glassblowing, and his work has been an exploration and extension of those traditions. This museum is fortunate to own a retrospective collection of his work. The museum's interest in glass, however, extends beyond its collection of Chihuly's work — the artists' use of glass in nontraditional ways is the motivation for organizing this show. The artists in this exhibition come to glass from a completely different orientation to the medium.

The significance of this show for the Tacoma Art Museum is also revealed in the selection of artists, who have intentionally been included to represent a national as well as a regional spread. The perspective established by this choice attests that glass is indeed an important material in the repertoire of contemporary artists. Catalogue essayists Kim Levin, a critic for *The Village Voice* in New York, and Ron Glowen, an art writer and historian living in the Northwest, also reflect the exhibition's national and regional scope.

We are grateful to guest curator Ginny Ruffner. From her conception of the exhibition to its planning and organization, her example and enthusiasm have been inspirational.

We wish to give special acknowledgment to the Schomburg Center for Research in Black Culture, the New York Public Library, for the generous loan of *Cakewalk Humanifesto: A Cultural Libation* by Houston Conwill, Joseph De Pace, and Estella Conwill Majozo.

We are confident that *Glass: Material in the Service of Meaning* will introduce exciting new ideas in the use of this medium.

Wendell L. Ott
Director, Tacoma Art Museum

Introduction

Ancient and modern, fragile and strong, opaque and transparent, hot and cold, precious and mundane, liquid and solid, the fabric of modern skyscrapers and jewels of ancient Egypt, glass has sustained its mysteries and attractions for over two thousand years. The evocative qualities of glass and its often-cited contradictions have provided endless enticement for curious artists, from that paradigm of enigmatic artmaking, Duchamp's *The Large Glass* (1915–23), to the present.

Though glass has a long and diverse functional history, which includes ornamentation, prosthetic eyeballs, domestic novelties, and scientific apparatus, the history of individually made studio glass is relatively brief, dating from 1962. The past thirty years have been marked by many technological advances in studio glassmaking and increased skill on the part of artists as well as a flowering of diverse methods of glassmaking — fusing, *pâte de verre*, lampworking, kiln casting, and mixed media. We are, however, at a critical juncture in glass history, a juncture identified with a climate of new ideas about glass and its place in the larger continuum of art.

Traditionally, the role of art in the western world has been to reveal and interpret the nonart experience. Currently, the central artistic issues in glass are shifting from such concerns as how an object is made and perceived, or what defines its style, to considerations of why art is made and experienced, and what a work of art means or signifies beyond the experience of its formal, stylistic, and material ingredients.

The purpose of this exhibition is to contribute to that dialogue specifically as it pertains to ideas about the future and validity of glass art. Currently the field of "glass art" is awash in objects, many beautiful, some ugly, most about glass itself — material as content. But if this medium-specific subgroup is to progress beyond a fascination with the materials, the evocative contradictions of glass have to be pursued more aggressively, manifested more succinctly. There have been many superficial depictions of beauty but few examinations of the meaning of beauty through a material that so successfully conveys it. I am distressed but not pessimistic by the current state of affairs. Like an individual artist's development, glass has progressed from skill-learning to the threshold of the inevitable door of content, and, like all turning points, this one appears to be, and indeed is, a crisis. But because artists will continue to find glass full of fascinating possibilities, experimentation will never stop, and glass will continue to be a material in the service of meaning.

Ginny Ruffner
Guest Curator

Looking for Meaning: Glass in Twentieth Century Art

Ron Glowen

If your style be of the ideal kind, you shall wreath your streets with ductile leafage, and roof them with variegated crystal — you shall put, if you will, all London under one blazing dome of many colours that shall light the clouds round it with its flashing as far as the sea. And still, I ask you, "What after this?" Do you suppose those imaginations of yours will ever lie down there asleep beneath the shade of your iron leafage, or within the coloured light of your enchanted dome?

John Ruskin, lecture to the Architectural Association, London, 1857

Glass is an ancient manufactured material. Thus, from the beginning, glass was intended for utilitarian purposes, including the production of artistic forms, which were — and to some degree still are — largely confined to architecture and functional as well as to decorative forms. Unlike the inherently valuable gold or gemstone, glass is derived from humble substance. Its original value and meaning resided primarily in its transformations, both alchemical (basic sand into fragile, precious glass) and phenomenal (transmitter of light, color, reflection). The contemporary so-called studio glass movement of the last three decades is largely predicated on esthetic concepts and uses for glass that are five thousand years old, updated to contemporary standards of taste.

When John Ruskin addressed London's architects, Joseph Paxton's Crystal Palace of 1850–51 was still brand-new. This secular temple must have had some appeal for Ruskin (certainly for its scale and technological brilliance), but it was for him a product and symbol of the Industrial Age. While Ruskin's "crystal dome" with the vaporous colors of J.M.W. Turner seems to call for an outpouring of medieval handiwork on an immense and impractical industrial scale, he recognized a real and potential impoverishment of artistic merit and meaning. Ruskin's statement resurrects past meaning in light of recent consequences, looking backward and forward in compressed fashion, as if viewing through a lens. This was not the discourse of modernism — the medievalist mentality of the Arts and Crafts movement (encouraged by Ruskin) may have given glass its first efflorescence in the modern age, but it was more retrograde than avant garde. Even so, the moral and political subtext of the Arts and Crafts movement gave rise to a new prominence for glass amid the general enthusiasm for the design arts.

More successful in its prophecy, but even more expansive in its utopian urges, was the obscure essay *Glasarchitektur* (1914) written by the visionary German poet Paul Scheerbart (1863–1915). Scheerbart, a member of Berlin's bohemian milieu, had a futurist bent that predated even F. T. Marinetti, author of the Futurist Manifesto of 1909. His book outlined over a hundred prospective uses for glass in future built environments. From

lighted glass structures as beacons for airplanes to the creation of a glass culture that would completely transform humankind (including the elimination of all esthetic pursuits except for the contemplation of glass), Scheerbart's rose-colored vision attracted a few disciples and has produced some tangible effects. He was a direct influence on architect Bruno Taut's (1880–1938) amazing Glass Pavilion for the 1914 Werkbund exhibition in Cologne, a small structure both technologically advanced and mystically spiritual. On the fourteen sides of Taut's Glass Pavilion, Scheerbart provided clever haiku-like couplets extolling the virtues of glass (some samples: **Colored glass/ Destroys hatred; Bricks may crumble/ Colored glass endures;** and in the hygienic future **Parasites are not nice/ They will never enter the glass house**).

In turn, Taut was responsible for spreading the gospel of glass among the corresponding architects of Der Glaserne Kette (Glass Chain group), and produced an even more utopian scheme in his 1919 sketchbook treatise, *Alpine Architektur.* Taut envisioned a fantastical transformation of the landscape — indeed, entire landforms and continents — with glass cathedrals, temples, waterfalls, mountains, and fields.

In these contexts, glass was symbolic of dematerialized matter, standing for the concepts of purity and perfection. As a material, however, glass was regarded more for its industrial associations than for its metaphysical potential. Glass often found its way into the design projects of Bauhaus and De Stijl instructors and members: Josef Albers (director of the Bauhaus glass workshop), Johannes Itten, Laszlo Moholy-Nagy, Theo van Doesburg, and others sometimes incorporated glass (or its substitute, plastics) in the process of their material and formal investigations.

Painting or Sculpture
Flat container. in glass — [holding]
all sorts of liquids. Colored, pieces
of wood, of iron, chemical reactions.
Shake the container. and look
through it ——
Marcel Duchamp, *Notes for The Large Glass,* 1914

Glass products became a part of the environment of the modern industrial age, but did not necessarily convey the redemptive powers that Ruskin or Scheerbart were seeking. Glass was on the shelf but not on the pedestal. The first major figure in twentieth century art to be associated — albeit somewhat peripherally — with glass was (depending on your point of view) the genius/nihilist/seer/charlatan/visionary/dilettante Marcel Duchamp, whose oeuvre is dominated by a work in glass, *The Bride Stripped Bare by Her Bachelors, Even* (1915–23).

Duchamp's celebrated "esthetic indifference" was manifested in glass numerous times during the making of *The Large Glass,* as *The Bride Stripped Bare . . .* is often referred to.

He incorporated or used glass elements in ways that would anticipate by decades several major contemporary trends, themes, attitudes and issues: the hinged construction using industrial materials attached perpendicular to the wall (*Glider with Water Mill*, 1913); readymades (*Paris Air*, 1919), cybernetic sculpture (*Rotary Glass Plates-Precision Optics*, 1921), random occurrence and variability (*Dust Breeding*, 1920, for *The Large Glass*); simulation (*Beautiful Breath, Veil Water*, 1921), and conceptual strategies (*The Brawl at Austerlitz*, 1921, made by a carpenter according to Duchamp's instructions).

Given Duchamp's philosophical penchant for subverting the meaning of art, is it possible that he chose to work with glass precisely because it did not connote any esthetic meaning at all? Obviously he did not use glass in any traditional artistic sense, and he was not proposing a new esthetic of glass, so the answer must be yes. But in Duchamp's glass works, as in all of his projects, he asks us to consider the element differently. Glass is the vehicle that advances Duchamp's excursions into the realm of perception, conceptually and visually. As a material its transparency is taken at face value — it is dematerialized matter that connotes a null, transient, or absent state.

An insight into Duchamp's use of glass can be extrapolated from remarks pertaining to his well-known denigration of so-called "retinal art": **By the retinal approach I mean that the esthetic delectation depends almost exclusively upon the sensitivity of the retina without any auxiliary interpretation. . . . Like Alice in Wonderland [the young artist of tomorrow] will pass through the looking glass of the retina to reach deeper mines of expression** (Duchamp, lecture, Philadelphia Museum College of Art, 1961).

Other explanations offered for his use of glass involve the perceptual ability to translate vision to a higher dimension (stereoscopic devices, mirrors suggesting a three-dimensional infinity) or the alchemical purification of base mineral matter into a substance that can allude to air, water, or light (referring to Duchamp's latent interest in the occult). The most important of them seems to be, put simply, the ability to see through physical matter to grasp a higher mental perception. Glass provided the perfect material metaphor for accomplishing this.

The calamitous regions of time are far from the comforts of space. The artificial ingenuity of time allows no return to nature. Mirrors in time are blind, while transparent glass picks up reflections in this spaceless region of inverse symmetry and shifting perspectives — the mirror reflects the blank surface in the suburbs of the mind.
Robert Smithson, unpublished essay, "The Shape of the Future and Memory," 1966

The boundaries of art reshaped by Duchamp were reconfigured again in the late 1960s. Duchamp's influence upon contemporary artistic thought remained something of a "glass shadow" until the 1950s. Glass might be used incidentally in assemblages (for instance, Robert Rauschenberg's *Coca-Cola Plan*, 1958) as a signifier of consumer commodity or

exhausted function, but it was not the major vehicle for transmitting Duchamp's ideas. The phenomenological art of the mid and late 1960s investigated properties of sight and space, often in works by artists using plate glass and mirrors (Larry Bell, Robert Morris), neon (Chryssa, Bruce Nauman, Keith Sonnier), or, in conjunction with the new technology of video, the glass screen of the television set (Nam June Paik, Nauman).

For similar reasons, the use of glass in the work of Robert Smithson serves the exploration of perception. Glass and mirror were key components in Smithson's theoretical investigations of time, place/displacement, and process. Geological structure, crystallography, and entropy were not only Smithson's operating principles but often his *mise en scène* as well. His *Enantiomorphic Chambers* (1964) was a structural demonstration of a crystal pattern using mirrors that effectively cancelled each other. An early and nearly realized land project, *Vancouver Project: Island of Broken Glass* (1970) would have covered a small rock island in the Georgia Straits with piles of shattered glass, a gleaming crystal on the horizon that would, entropically, return to the original form, sand, in time.

The contemporary use of glass veered away from tradition in more than one respect. Its manufactured form was taken as a given while new meanings and uses were assigned to it. Physical manipulation of the material was either additive or entropic; there was little possibility of actually forming the glass itself, nor did the artists involved in Minimalism and Conceptualism care to. Independently, however, the means of forming glass in its molten state within a small or individual studio setting was achieved in the early 1960s, inaugurating the studio glass movement. The modernist search for innovative form was combined with the conventional and traditional practices of glass craft and artisanship in the making of decorative, functional, and small sculptural objects.

Though glass was, at this historical juncture, conveniently dichotomized into categories of "high art" and "craft," the differences were perhaps more theoretical. For both Duchamp and Smithson, glass was linked to the concept of time, however obliquely it may have been stated (Duchamp's subtitle for *The Bride Stripped Bare* . . . is "a delay in glass"). But the processes and techniques inherent to a crafts esthetic are hedges against time, against entropy and decay in favor of durability and permanence. The dominant ideologies of late modernism — Minimalist neutrality, process art, Conceptualism — downplayed or eliminated the importance of the permanent art object and the stylistic signs of artistic signature, aspects which were central to the resurgence of studio glass. And while studio glass gave reason to celebrate and link up with tradition once again, the tenets of late modernist art continued in its oppositional stance.

A bit of iconoclasm was necessary if these modes were ever to converge. The nascent studio glass movement was not entirely wedded to traditional craft esthetics, and by the early 1970s the end-game strategies of pure formalist art and philosophical conceptualism seemed empty or bankrupt. Oddly, at this time it would seem the two modes began to work against themselves. Experimenters like Dale Chihuly and Jamie Carpenter at the Rhode Island School of Design were pushing the boundaries of studio glass. But artists of mainstream painting and sculpture embarked on a search for meaning and reference in areas

external to modernist formalist tenets or from within history and tradition. Eclecticism rather than purity became the goal, allowing for more avenues of meaning, though it has resulted in the ambivalent state of affairs known as pluralism.

The exhibition *Glass: Material in the Service of Meaning* originates at the juncture of late modernist iconoclasm within high art and craft. It proves unnecessary to distinguish between "glass artists" and artists who use glass, for it is not the starting point but the completed idea that takes precedence. The continuing interest in material expression among contemporary artists has taken advantage of a "window of opportunity" provided by the promoters of a glass esthetic. Glass-oriented institutions such as the Rhode Island School of Design, the Pilchuck Glass School, and the New York Experimental Glass Work- shop offer their facilities and technicians to contemporary artists wishing to use glass as a material element in their work. Traditional methods of forming, decorating, and fabricating (blown glass, casting, etching, engraving, painting, etc.) are now commonly employed by artists of nearly all modernist and post-modernist persuasions.

Italo Scanga, one of the first artists to step across the boundary, began to use blown glass elements in his assemblage installations and sculptures of the early 1970s. He con- tinues to incorporate glass components in his exuberant, referential, quasi-narrative constructions. Laddie John Dill's signature use of industrial mediums such as concrete, minerals, and glass in abstract textural relief paintings since the 1970s is now manifested in a corner-relief installation sculpture using glass to physically and phenomenally defy gravity.

Gary Hill and Norie Sato use the illumining video screen as a source of light and motion as well as a technological and communicative (i.e., language) reference. Glass is both the source of light and its receiving aftermath. The notion of projection is used in its modern visual sense (cinema, television, or video) as well as its phenomenological sense (to carry or transmit, in this case light waves of information). Both artists employ video as a tautological structure referring to its electronic origins. A tautological structure is also evident in Dennis Oppenheim's work, employing recorded sounds that refer to the blown glass object in the context of its formally and functionally evocative processes and qualities.

The inclusiveness of art styles and movements since the early 1970s has resulted in the hybrid work of art — one which transcends narrow categories of style, material, technique, format, meaning, reference, and source. A materially inclusive style or approach is taken by artists such as Judy Pfaff and John Torreano, whose work is primarily abstract in form and reference but makes considerable use of real objects and forms, blurring the distinction between abstraction and actuality. Neither is a reductivist — the joyous, playful, and ornamental character of their work reveals itself in the multitude of forms, shapes, colors, and textures employed. The glass elements, among the rest, have a certain "thereness" as a readily available material and form.

Though glass is inorganic, its fluid properties and fragility are useful as biological metaphors. There is the additional notion, only recently expressed by a number of glass artists, pertaining to the biological process involved in glassblowing. That notion is breath:

life-giving as well as form-giving. The works of Nancy Bowen, Deborah Dohne, Nancy Mee, and Jill Reynolds have specific biological references. The incipient organic growth forms by Bowen, the captured breath in globular forms in Dohne's work, the ganglia-like tentacles and gestated head-forms of Reynolds, suggesting the awakened consciousness, examine glass in the state of becoming. Nancy Mee's morphological associations of glass beauty and fragility with human idealism and pathology is perhaps more entropic with respect to the state of being, but nonetheless the human and biological connotations take precedence as meaning.

Glass is so ubiquitous in modern society that it is no longer associated with only its former industrial or traditional artistic roots. As a figure of speech, as consumer goods, scientific apparatus, preservative and protective device, as symbol of progress, of social malaise, and ethnic origin, the meanings inherent in glass forms and references are more widespread and profound than ever before. Buster Simpson is a self-proclaimed "street artist" whose artistic practice often takes the form of urban ecological intervention. He once erected a target site near a Seattle hangout for transients so they would toss their empty liquor bottles into a recycling bin (*Crowbar Bottle Trap*, 1982–83). His is not a curative for social disorder but the acknowledgment of its condition, intended instead to assimilate with its particular social dynamic. On the other hand, Joyce Scott's glass bead doll-figures pay homage to folk and ethnic craft traditions while injecting direct social and political messages regarding sexism and racism. Both Simpson and Scott directly associate glass elements with social values and situations.

The works of team-artists Houston Conwill, Joseph de Pace, and Estella Conwill Majozo, and Kate Ericson and Mel Ziegler are specific to place. Their works generally take into account the historical, mythological, evolutionary, and symbolic concepts that define region, place, or social group. Glass may or may not be an essential component within these working parameters, but each artist has used glass as a means of translating and expressing those components.

A certain instrumentality pervades the work of Mel Chin, Donald Lipski, Susan Plum, and Kiki Smith, and to a lesser degree the work of Mark Calderon. That is, the glass elements used or made for the works seem to have — or did have — another intended purpose. But in this transfer of utilitarian meaning, the resulting works are infused with a compelling, irrational, and evocative mystery. Filling a glass container with unexpected sensually tactile materials ripe with class associations (the work of Mel Chin), or transposing the common treatment of organic preservation in glass containers into industrial or scientific vessels (Donald Lipski) elevates the ordinary into a surrealistic zone. Calderon's juxtapositioning of glass and other utilitarian forms renders them strangely magical and symbolic.

To a certain degree, a biological reference is contained in the work of Plum and Smith, though it merges with the machine. The quasi-vehicular constructions of Plum seem to have traversed time and space from a distant planet, while Smith's cross-sectioning of the human head explores the metaphysicality of inner space.

Critic and theoretician Jack Burnham has suggested that the only innovation possible in art is the removal (or inversion) of signifiers. It seems quite important for the artists represented in *Glass: Material in the Service of Meaning,* that the significant element retain its preeminence within the work of art, though inversion is a quality that characterizes the meaning, process, and reference in many of these works. The range of signifiers in art has, it seems, been expanded by those who are compelled to invoke ideas, concepts, attitudes, and expressions beyond the hermetic and self-reflexive conditions that existed twenty years ago, when Burnham made his remark. It so happens that glass — as product, element, form, and phenomenon — is a fundamental vehicle for signification and meaning in contemporary art and life. The house of art is made from glass.

Transparent Contradictions

Kim Levin

Glass, to be absolutely precise, is a liquid. Try telling that to anyone who has just cut a hand on a jagged piece of it. But the dictionary insists that, having solidified from a molten state without crystallization, glass belongs to a class of transparent or translucent materials that "are regarded physically as supercooled liquids rather than true solids."

All but invisible, this ordinary material we tend to take for granted offers a mass of contradictions. It is dangerous and vulnerable, fragile yet strong. It can shatter into smithereens or catch the light to sparkle like a gem. An invisible barrier, it's less to be looked at than to be seen through. Fully as wondrous as another solidified liquid, ice, in Gabriel Garcia Marquez's fictional town of Maconda, glass is also a versatile substance. It can be cast, blown, ground, stained, etched, painted, sandblasted, or spun.

Glass is hardly a new material in art. No sooner had early modern painters rejected the notion of the canvas as a window onto illusive space, focusing instead on the flat surface, than Marcel Duchamp began playing with the paradox of a transparent surface through which the real world could literally be seen. His diagrammatic masterpiece, *The Bride Stripped Bare by Her Bachelors, Even,* also known as *The Large Glass,* is a work in glass, on glass, and of glass. Its format and abiding metaphor is, literally, a window. Wander through the history of modern art and you'll find that glass makes a surprising number of cameo appearances: in Henri Matisse's stained glass windows at Vence it's a picture surface; in Joseph Cornell's boxes it's a goblet, aggie, or other allusive object; in H.C. Westermann's little houses it's a construction material. Even Picasso once painted a picture — for a documentary film — on glass. In the development of modern architecture, glass has played a major role.

In the 1960s and 1970s, artists such as Larry Bell, Lucas Samaras, Robert Smithson, and Patsy Norvell — creating spectral cubes, jagged shards, glittering fossils, or ornamented screens — worked with glass. So, in his own way, did Chris Burden when he did a performance piece in the early 1970s, in which he crawled through fifty feet of broken glass. John Torreano, whose jeweled abstractions gained attention during the time of the exuberant Pattern and Decoration movement of the late 1970s (when painters and sculptors borrowed from textile design and other crafts), has long embedded constellations of faceted glass "gems" in the surface of his works. Other established artists — Dennis Oppenheim, Italo Scanga, Judy Pfaff — have used glass along with a variety of other materials and objects in some of their mixed media works. Nicholas Africano, known since the 1970s for his narrative paintings, began making frosted glass figurines touched with cosmetic color a few years ago. Recently, incorporating plaster and stone as well as glass, he has increased their scale to lifesize.

What's curious is that in the past few years, at a time when much new art has been distanced, cryptic, and opaque — armed against vulnerability — this fragile, transparent material has also gained widespread appeal for a newer generation of artists. They're not

working in the traditional vein of art glass, like Dale Chihuly. The new work has a wayward materiality and conceptual overtones of social responsibility, as well as precariousness and domesticity.

The artists in this exhibition aren't the only ones who are now using glass. Other artists, whose work is usually thought of in other contexts, have made interesting use of glass in the past few years. Louise Lawler's work, focusing on the way museums and private collectors display their collections, critiques the uses to which art is often put. In some of her installations, glass tumblers or goblets accompany her photographs of details of works of art in display contexts. Lined up in neat rows on shelves, they bear unnerving mock cocktail-glass slogans ("It costs $5,900,000 a day to operate an aircraft carrier"). Her work, insinuating that art has become an expensive commodity, implicates the viewer as a consumer of art in a broader social context of skewed priorities, in which defense spending outweighs medical care.

Barbara Bloom, who received the Young Artist award in the 1988 Venice *Biennale,* combines photographs, furniture, and other custom-crafted or antique objects, including glass bowls and decanters that are sometimes displayed like valued possessions in genteel cabinets. Delicately etched with acerbic texts, these customized objects become narrative details in installations that elegantly interrogate modes of display, while commenting on historical memory and artistic ego.

Maura Sheehan, whose installations often refer to the classical past as well as current social ills, has painted a series of Athenian black-figure vases on laminated glass wind-shields, and a trio of Gorgons on round glass floormats. She has also done glistening wall-to-wall floor installations of cracked auto glass that crunches when walked on.

Matt Mullican sometimes depicts the enigmatic signs and symbols of his private cosmology in stained glass. Robin Winters, whose paintings were always haunted by crowds of human heads, has recently shown installations of blown-glass vases with crude faces and shelves full of lumpy blown-glass heads. Hungarian-born artist Orshi Drosdik combines glass with other materials and objects in her pristine conceptual installations, which carry biological and botanical allusions; she might restate Linnaeus's system of plant classification, or scatter porcelain blood platelets across the floor: both become markers for psychological states. German artist Rebecca Horn, who won the Carnegie International prize in Pittsburgh in 1988, often incorporates glass funnels and beakers — along with tapping shoes, flapping paintbrushes, sparking wires — in her narrative kinetic work, which confounds mechanical repetition and ephemerality.

Even Sherrie Levine, whose reputation is in the conceptual realm of appropriation, has worked with glass. In 1989 she exhibited six frosty cast-glass objects which were opaque, three-dimensional realizations of some of the diagrammatic "bachelors" in uniform from Duchamp's *The Large Glass.* It was as if Levine had reconstituted to dense sculptural solidity the enigmatic forms Duchamp had originally derived from hollow chocolate molds (in the shape of priest, postman, bellhop, soldier). Each of her doubly distanced abstract objects was encased behind glass, as if hermetically sealed in its own handsomely crafted vitrine.

The vitrine itself — a glass display case with an elaborate or simple wood or metal frame — has become an increasingly popular format for artists lately, thanks to Fluxus tradition and the work of Joseph Beuys and Marcel Broodthaers as well as theoretical treatises focusing on art as commodity. Vitrines provide an enclosing cubic form that can isolate a single piece or unify a number of pieces. But even more crucial to recent art, they provide a context that shifts our train of thought from esthetic issues to issues of natural or social history, and to modes of representation and display.

The concern for content is also what unites the work of the artists in this exhibition. For them, as for many artists today, meaning is more important than material or form. Donald Lipski, whose transformations of ordinary objects bear a magician's touch (and indeed he was trained as a magician), goes a step beyond the vitrine in his series of glassed-in objects called *Water Lilies*. In these liquid-filled wall pieces made of glass tubing and sealed with gaskets, he embalms grasses, flowers, vegetables, and fruits. The hermetically sealed plants, preserved in an unnatural state of perpetual, inedible, formaldehyde freshness, defy putrefaction.

Houston Conwill, working with his poet sister Estella Conwill Majozo and architect Joseph De Pace, uses the transparency of glass in large site-specific installations, such as *The New Cakewalk*, to suggest the invisibility of Black history. Their collaborative work is concerned with the preservation of a cultural heritage. Full of cross-cultural references, the pieces rechoreograph African American contributions, integrating them into the standard version of American history and into the history of the work's specific site. In the process they reverse the old stereotypes and provide a new model for future histories.

Kate Ericson and Mel Ziegler also collaborate on work that's site-specific and involved with America's social history. They, too, often use glass. Visually simple and conceptually complex, their projects involve existing systems of labor and production. Whether sand-blasting the names of anonymous laborers onto glass plaques (for a project they did at New York's Museum of Modern Art); shelving a long row of Mason jars filled with home-canned fruits and vegetables (each emblazoned with a sandblasted leaf from the plant whose fruit is within) on a gallery wall; bronzing heavy farm machinery for exhibition and then returning it to the farmers; or exhibiting a wallful of old Washington, D.C., factory windows bearing memories of their former site, Ericson and Ziegler are concerned with traces of prior existence, with conservation and preservation. Their art plucks its materials from the world and vanishes back into the world.

Mel Chin's objects and installations, making unusual use of unexpected substances, might seem to be handsome formal work if you don't bother to decipher their content. But they're also intricate allegories, which may incorporate astrological, alchemical, psycho-politico-historical, or ethnic information along with glass, silk, tin, and linseed oil. While his process-oriented work has always contained a planetary symbolism, recent works in progress have begun to deal with ecological concerns. In a current project called *Revival Field* (1991), Chin has planted a symmetrical formal garden (in the pattern of a cross-hair target) on a toxic waste site: plants known as hyperaccumulaters will absorb cadmium and lead from the contaminated earth, detoxifying the ground in the process. Another current

project, *State of Heaven,* is a magic carpet representing the earth's ozone envelope. The large floating carpet will have a hole in its center that's a scale model representation of the ozone hole, and it will be unraveled or rewoven from time to time to reflect the depletion or replenishment of ozone in our atmosphere.

Kiki Smith focuses on the frailties of the human body. In her work, glass is one of a number of substances used to replicate human organs and parts. Among her works are a series of clear and frosted glass stomachs, and a row of glass babies filled with water, as well as a terra cotta ribcage and an iron intestinal tract which resembles a radiator. She has also etched the names of twelve body fluids, including blood, sweat, urine, and tears, in German Gothic lettering on a dozen elegant, silvered, five-gallon glass jugs. Last season she exhibited a large group of crystal spermatazoa on a rubber mat in the Museum of Modern Art's Projects Room; her contribution to the 1991 Whitney Biennial was a pair of lifesize and lifelike nude wax bodies hanging limply, like meat. Says Smith: "I like glass first because it's a liquid. It's always a reminder that things aren't what they appear. It's a material that has a spiritual quality. It's pure: molten glass is incredibly sexy too."

Other sculptors are making use of glass for its abstracted overtones of vessel and body, for its spiritual translucence, its physical properties, its social allusions, and for its adaptability. It's a chameleon material that seems somehow perfectly suited to the concerns of many artists now. Whether feminist or ecological, ethnic or sociological, content now matters in art more than form. Meaning matters more than composition. Presentation matters more than innovation. Survival is more important than progress, as we've come to realize. Life is more crucial than art.

Glass, the solid-state liquid, reflects the ambiguities, ambivalences, and contradictions that artists have confronted lately. Whether building glass structures, printing slogans on tumblers, etching or sandblasting images and information on Mason jars or water jugs, making blown-glass mutant abstractions or cast-glass sculpture in the shape of stomachs, sperm, or soldiers, artists are making new use of this paradoxically solid, brittle material. They're using glass in ways that speak of wreckage and survival, loss and preservation, impermanence and sustenance, the fragility of nature and society and cultural memory — in a volatile, transitional, and insecure world in the process of shattering and coalescing into new configurations. At the tail end of the modern century, glass is a material conveying new, urgent content.

This essay is an expansion of an article that appeared in *Glass,* Spring/Summer 1990.

Nancy Bowen

Born in 1955 in Providence, Rhode Island
Lives in New York

1990 M.F.A., Hunter College, New York
1978 B.F.A., School of the Art Institute of
Chicago
1973—75 Stanford University, Palo Alto,
California

**Who now lives in the hollowed hearts and
jugs [of Bowen's sculptures]? Identification
with the home even of one's own body will
never be the simple analogy possible 40
years ago. Rapidly shifting circumstances
and values complicate female sexuality for
Bowen's generation, which grew up with
mandates for greater responsibility to
"our bodies/ourselves," responsibility
more than one Supreme Court justice
would like to take back. This home-on-the-
edge is the psychic environment for a
sexuality of the body in parts still split
hopelessly from mind and spirit**

**"Housed" in the biomorphic
vocabulary of the earlier 20th century and
Brancusi, Moore, and Bourgeois, Bowen's
sculptures live in today's chaotic contradic-
tions. "The forms are all there to be
recombined," she says. In her bionic
reconstruction, a new hyphenated atlas
spans modernist abstraction, while
bursting the boundaries of her references
and seeping hotly into awareness of sexual
complexity we are still afraid to see
straight on.**
Arlene Raven, "Hollowed Hearts," *The Village
Voice,* March 3, 1987, p. 6

Works in exhibition:

Ampulla, 1990
Plaster, wax, glass, and steel
64 x 34 x 14 in.*
Courtesy of Betsy Rosenfield Gallery
Illustrated

Globus Hystericus, 1990
Plaster, glass, and steel
55 x 26 in.
Courtesy of Betsy Rosenfield Gallery

Third Eye, Heart, and **Navel,** from
Seven Aspects of the Body, 1989—90
Glass and steel
3 shelves, 11 x 7 in. each
Courtesy of Annina Nosei Gallery

*Height precedes width precedes depth, unless
otherwise noted.

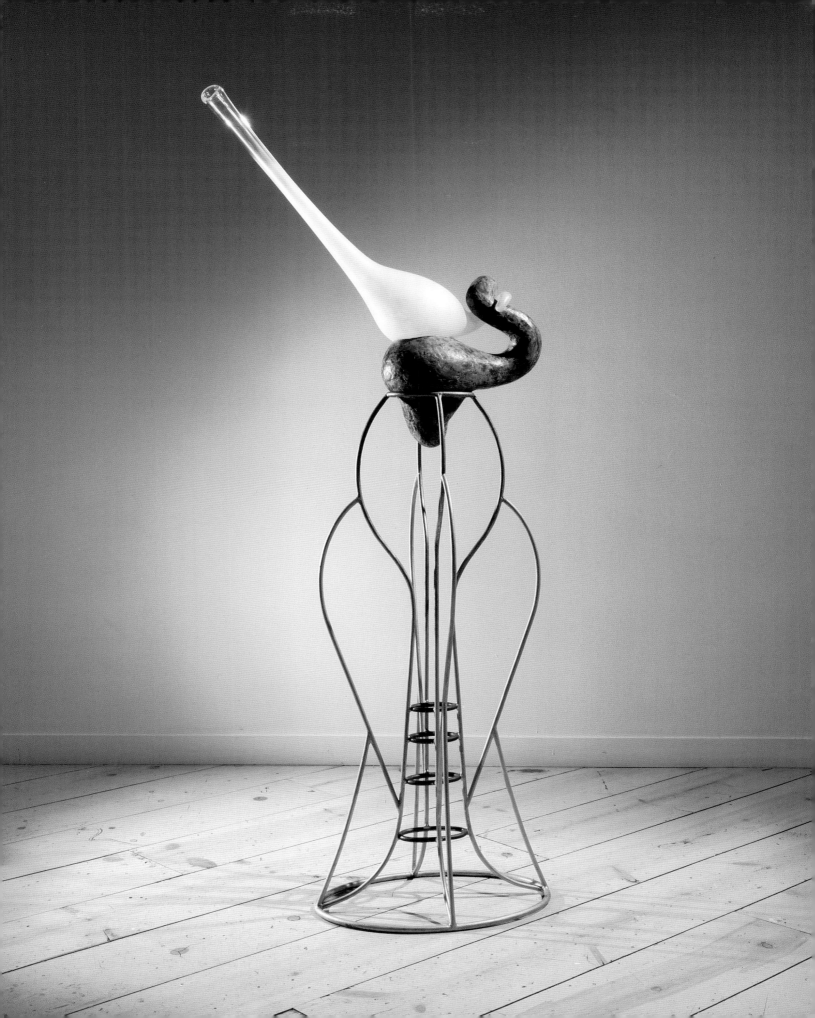

Mark Calderon

Born in 1955 in Bakersfield, California
Lives in Seattle

1978 B.A., San Jose State University, California

The most recent works . . . turn universal emblems such as the cross into evocations of private experience. All the pieces combine richly modulated surfaces, subtle shapes, and symbolic imagery. These elements, corresponding in a rough way to the sensuous, the intellectual, and the spiritual, interrelate to create drama and complexity in seemingly simple paintings and structures.
David Berger, *Documents Northwest: Mark Calderon,* Seattle Art Museum, 1987

Work in exhibition:

Big Cage for Baubles, 1991
Steel, glass, rope, and wood
45 x 27 x 27 in.
Courtesy of the artist and
Greg Kucera Gallery
Illustrated

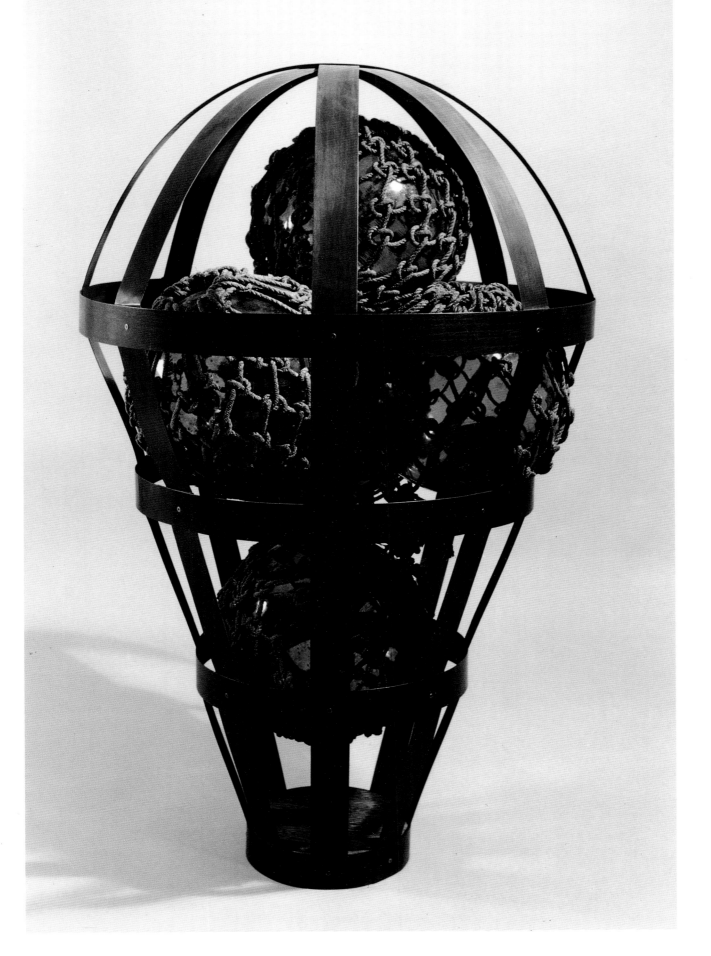

Mel Chin

Born in 1951 in Houston
Lives in New York

1975 B.A., George Peabody College for
Teachers, Nashville, Tennessee

**Selected Weapons [exhibition at Frumkin/
Adams Gallery, 1988] combines pieces
from two areas of Chin's interest: instru-
ments of torture and musical instruments.
Stated that way, the point of these works
might seem to be too easily reached: a
study in contrasts, a synthesis of opposites,
with perhaps some kind of victory or
reconciliation in the end. Fortunately,
things are never so simple; each piece is a
puzzle and needs to be worked through
patiently. Some of the objects displayed,
like the pair of Sun and Moon Knives, seem
to relate only to the aggressive end of the
scale, until you learn that these vicious-
looking blades, in Chinese romances of
chivalry, are supposed to sing when
thrown. Music, thereby, becomes some-
thing sinister and not just the (self-fulfilling,
pleasure-giving) antithesis to war: the
viewer is reminded of what goes into
making violin strings and drumskins**

 **In this as in other Chin productions,
materials are not merely vehicles to a
meaning but become ingredients of the
meaning.**

Haun Saussy, "Mel Chin," *Arts Magazine,* March
1989, p. 81

Works in exhibition:

Jupiter: Circulation and Self Sacrifice,
from **Operation of the Sun Through the
Cult of the Hand,** 1987
Glass, silk, wood, tin, and linseed oil
H. 53 in. x diam. 7 1/2 in.
Courtesy of the artist
Illustrated

Plot Marker, from **Revival Field,** 1991
Redwood, glass, bakelite, steel, aluminum,
copper, zinc, and lead
24 x 3 1/2 in.
Courtesy of the artist

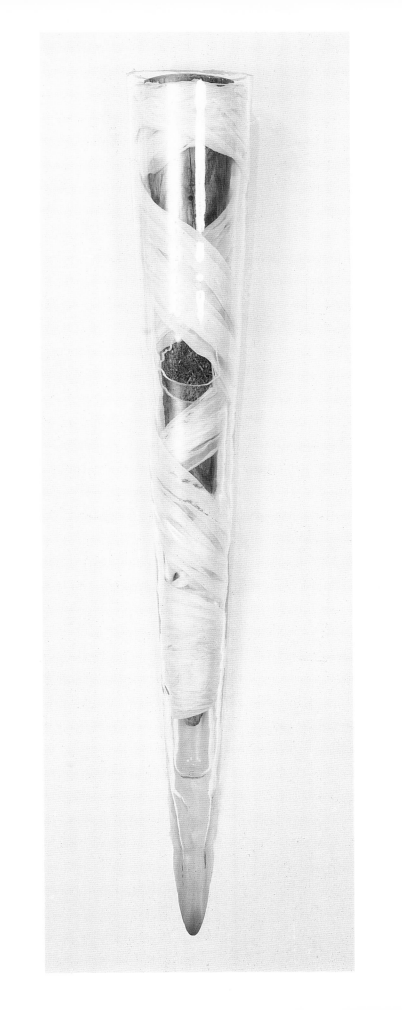

Houston Conwill

Born in 1947 in Louisville, Kentucky
Lives in New York

1976 M.F.A., University of Southern California,
Los Angeles
1973 B.F.A., Howard University,
Washington, D.C.
1969—70 University of Texas, Austin
1963—66 St. Meinrad Monastery, Indiana

We are an interdisciplinary team of
collaborating artists concerned with art as
it brings meaning to our lives and serves as
a catalyst for change. We create site-specific
public art installations which resonate with
the history of the site, rechoreographing
Black history with an impulse toward
freedom, opening the historical canon to
the diversity of multicultural voices. Our
works are both political and spiritual,
syncretizing traditional pan-African reli-
gions and mythologies with Catholicism.
We are concerned with the preservation
and communication of culture and wisdom
across continents and generations. We
intend our works to serve as vehicles for
education, presenting positive role models
for our children.
　　We are also concerned with unearth-
ing the spirituality buried in contemporary
secular existence. The works are inspired
by the spirituals and blues, which are in
the griot tradition (West African storyteller,
oral historian, shaman, musician, and
dancer). The sacred texts of the spirituals
doubled as both prayers to God for deliver-
ance from slavery and coded signal songs for
escape on the underground railroad. The
subversive and signifying secular texts of the
blues sound the rhythms and rhymes of
hope, affirming a belief system and a will to
survive rooted in a "blues philosophy" of
joyous triumph over adversity.
　　We create maps of language that
direct audiences on cultural pilgrimages and
journeys of transformation — rites of

Joseph De Pace

Born in 1954 in New York
Lives in New York

1982 M. Arch., Urban Design, Harvard
University
1978 B. Arch., City College of New York

passage through life and death to resurrec-
tion. We use collaged and edited quota-
tions from spirituals, blues, gospel, jazz,
soul, funk, and rap lyrics in dialect, and
critical voicing from the heroic models of
African American culture, whose pro-
phetic words reflect the values and
aspirations of the culture, functioning both
as a critique and a healing. These words
challenge us to break down barriers
between people of diverse backgrounds
and to build bridges of compassion,
illuminating a common ground of shared
human values. Our works are acts of faith.
The artists, written statement, 1991.
Houston Conwill is a sculptor, Joseph de Pace is
an architect, and Estella Conwill Majozo is a
poet.

Estella Conwill Majozo

Born in 1949 in Louisville, Kentucky
Lives in New York

1980 Ph.D., English, University of Iowa
1976 M.A., University of Louisville, Kentucky
1975 B.A., University of Louisville, Kentucky

Illustration (not in exhibition):

The New Cakewalk, 1988—89, installation
at the Williams College Museum of Art in
**Selections: Six Contemporary
African-American Artists,**
May 12—October 29, 1989
"Dance floor" collection of High Museum of
Art, Atlanta; other components courtesy of the
artists

Work in exhibition:

**Cakewalk Humanifesto: A Cultural
Libation,** 1989
Glass, steel, text, stones, and water
Approximately 10 x 8 x 15 ft.
Collection of Schomburg Center for Research
in Black Culture, The New York Public Library

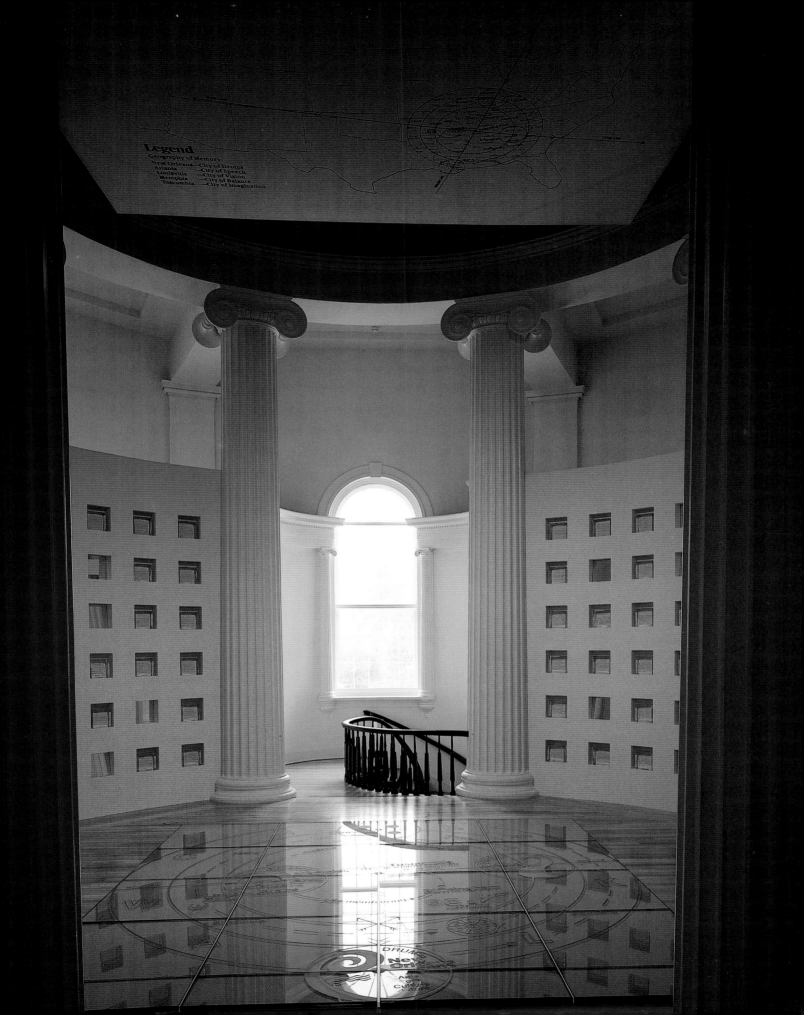

Laddie John Dill

Born in 1943 in Long Beach, California
Lives in Venice, California

1968 B.F.A., Chouinard Art Institute, Los
Angeles

**I come from a generation where the idea
for a sculpture was completed before the
execution. But what I'm trying to do is
incorporate expressionistic methodology
in relationship to that. A classic example
would be an early piece that I did with
sand and glass. The glass was set up in a
very highly complex geometric pattern,
simple in its arrangement but complex in
its finality — the way the light went
through it. The whole piece was suspended
in seven tons of sand that was arbitrarily
spread out, but the sand was very impor-
tant to the structure of the piece. It
actually was the substance that held the
piece together. As so as arbitrary as these
mounds appeared, they were very integral
to the structure of this architectural form.**

 **My present work reflects this
approach. There is a strong geometric
feeling and at the same time, an emotional
or expressionistic edge that's introduced.**
Dill, written statement, 1991

Work in exhibition:

Corner Piece, 1989
Glass and minerals
17 x 6 x 4 ft. (top); W. 1 1/2 in. (bottom)
Courtesy of the artist
Illustrated

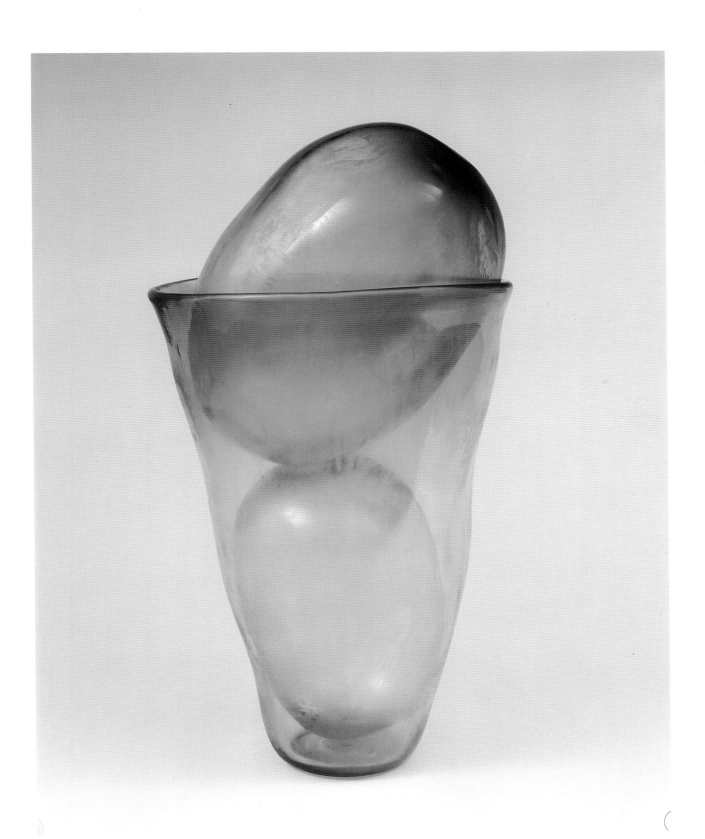

Kate Ericson

Born in 1955 in New York
Lives in New York

1982 M.F.A., California Institute of the Arts,
Valencia
1979 University of Texas, Austin
1978 B.F.A., Kansas City Art Institute, Missouri
1975 Sir John Cass School of Art, London
1973—75 University of Colorado, Boulder

**Time is a crucial element in the develop-
ment of social ideas and attitudes. We
have used time as a basis for our work.
Change inevitably occurs with time:
notions of public and private space evolve
over time. For example, the automobile
has greatly changed our attitudes about
public space. The shopping mall has re-
placed the town square as a public
gathering place. Using time allows work
to be pertinent to the moment and deal
with such changes in attitudes. . . .**

**We are interested in an art that can
be part of a common experience. Art has
the ability to be a valuable social tool,
but this function is often constrained by
art's insulation from day-to-day existence.
We want our work to be pragmatic, to
deal with pre-existing social systems, and
to carry on a dialogue with the public.**

Ericson and Ziegler, interview by Ned Rifkin,
Kate Ericson/Mel Ziegler: WORKS, Washington,
D.C.: Hirshhorn Museum and Sculpture Garden,
1988

Mel Ziegler

Born in 1956 in Campbelltown, Pennsylvania
Lives in New York

1982 M.F.A., California Institute of the Arts,
Valencia
1978 B.F.A., Kansas City Art Institute, Missouri
1974—76 Rhode Island School of Design,
Providence

Work in exhibition:

Dark on That Whiteness, 1987
Sandblasted glass and latex paint
147 x 192 in.
Courtesy of the artists and Michael Klein, Inc.
Illustrated

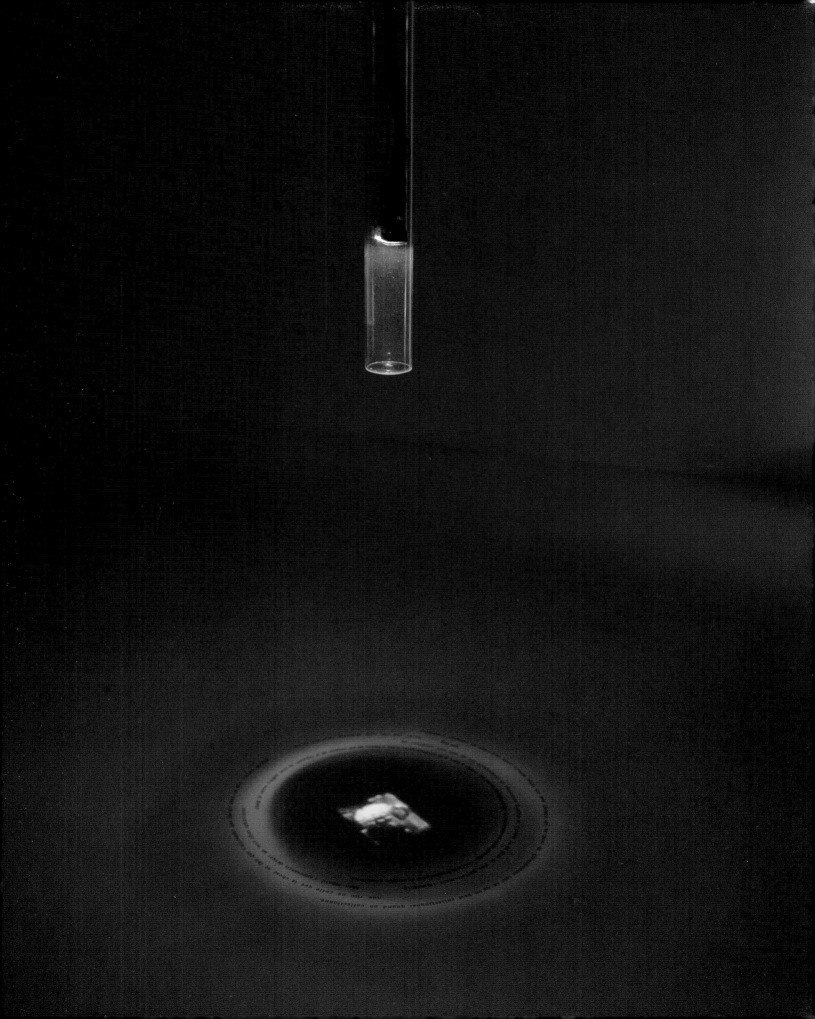

Donald Lipski

Born in 1947 in Chicago
Lives in New York

1973 M.F.A., Cranbrook Academy of Art,
Bloomfield Hills, Michigan
1970 B.A., University of Wisconsin, Madison

**The reason for having all this stuff around
is instant access. If I'm walking down Canal
Street or looking through a hardware
store in Sweden, if there's something that
appeals to me, if I think something is
substantial enough as an object, has
enough resonance, I just bring it home, not
for the sake of collecting, but to expand
my palette. . . .**

**I shy away from anything that's very
technical. I wasn't trained as a sculptor, so
I glue my stuff together, or tie it together.
I can melt wax on the stove and pour it in.
Fabrication takes much too long. Usually I
can even find the brackets that pieces hang
from. Same casualness with the wrapping.
If there is a form and I don't like the
surface of it for some reason, or just want
to clean up the form, I'll wrap it.**
Donald Lipski, "Sculptors' Interviews," *Art in
America*, November 1985, p. 124

Works in exhibition:

Water Lilies No. 40, 1989
Glass tubing, broken glass, solution,
and hardware
11 x 22 x 5 ½ in.
Collection of Mr. and Mrs. Robert M. Sarkis
Illustrated

Water Lilies No. 59, 1990
Glass tubing, onions, solution, and hardware
6 x 37 x 6 in.
Collection of Leonard Dobbs
Illustrated

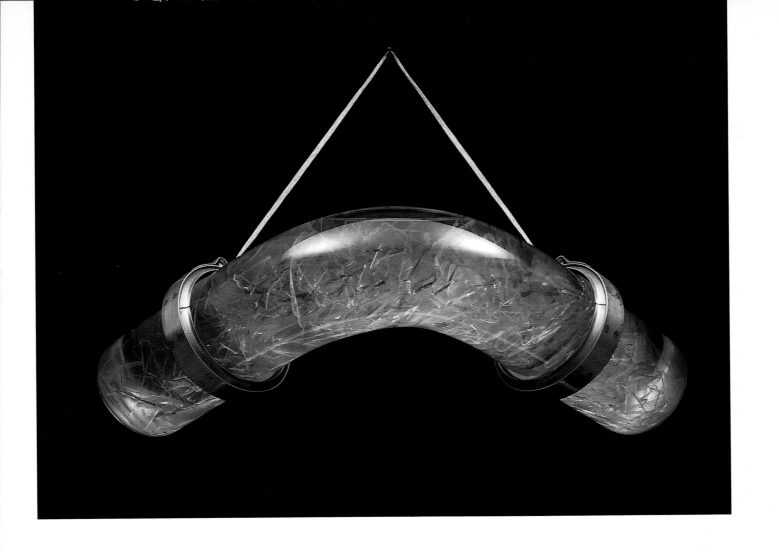

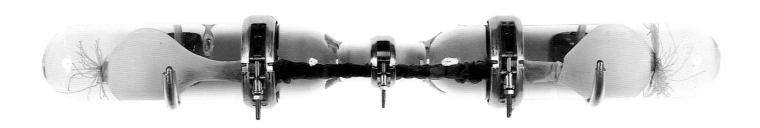

Nancy Mee

Born in 1951 in Oakland, California
Lives in Seattle

1974 B.F.A., University of Washington, Seattle
1972—73 American Center for Art and Artists,
and Atelier 17, S.W. Hayter, Paris

**The positioning of the *Venus de Milo* in
photographic form, in full-length and on
transparent glass, implies a number of
different meanings. It presupposes the
statue's status as an icon of popular as well
as high culture. As [Peter] Fuller pointed
out [in "The Venus and 'Internal Objects',"
Art and Psychoanalysis, 1980], the key to the
Milo's enduring appeal was the appropria-
tion by commercial advertising of the
statue's encoded status as the paragon of
female beauty. Mee undermines this
assumption by placing the photo image
next to contorted, metallic braces that
surround fused glass columns acting as
metaphorical containers for spinal fluid.
She . . . also reminds us, in the tradition of
Walter Benjamin, of the work's more
powerful and pervasive presence in the
late 20th century via photographic
reproduction.**
Matthew Kangas, "Rebirth of Venus: The
Persistence of the Classical in Contemporary
Sculpture," *Sculpture*, November/December 1990,
p. 54

Work in exhibition:

Hanging Healing, 1990
Steel and glass
82 7/8 x 46 7/8 x 21 in.
Collection of Tacoma Art Museum
Illustrated

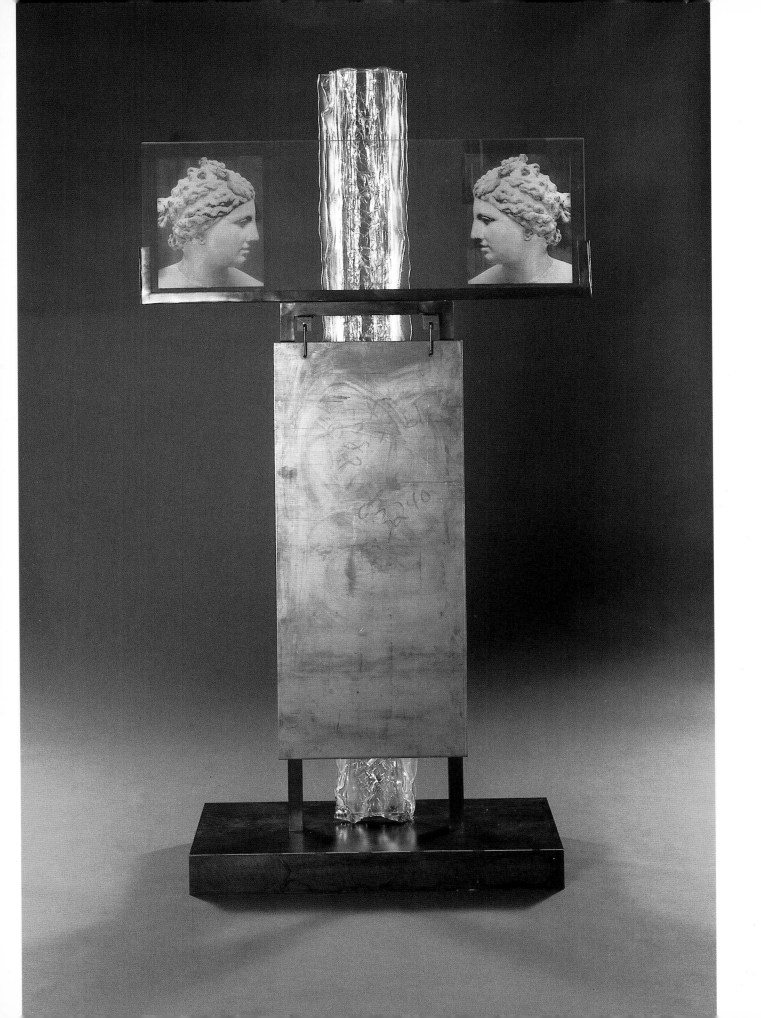

Dennis Oppenheim

Born in 1938 in Electric City, Washington
Lives in New York

1965 M.F.A., Stanford University, Palo Alto,
California
1964 B.F.A., California College of Arts and
Crafts, Oakland

**[My] work, as much of the work in the
seventies, required deliberation. All these
questions seemed to flood in and you have
to answer them; and finally, you might
be able to have a work, at the end of that.
You could never start at the other end,
and then ask questions. These things sift
into being through months and months,
pages and pages, and finally rise to a point
where I think it might be able to be built.
So I suppose that part of the journey that
I am taking has to do with meaning.**
Oppenheim, "Behind the Eight Ball with Dennis
Oppenheim," interview by Collins and Milazzo,
Dennis Oppenheim: Recent Works, Liverpool
Gallery, Brussels, 1990, pp. 10-11

Work in exhibition:

Bee Hive-Volcano, 1979/89
Glass, tape player, and sound track
3 pieces, each 18 x 12 x 12 in.
Courtesy of the artist
Illustrated

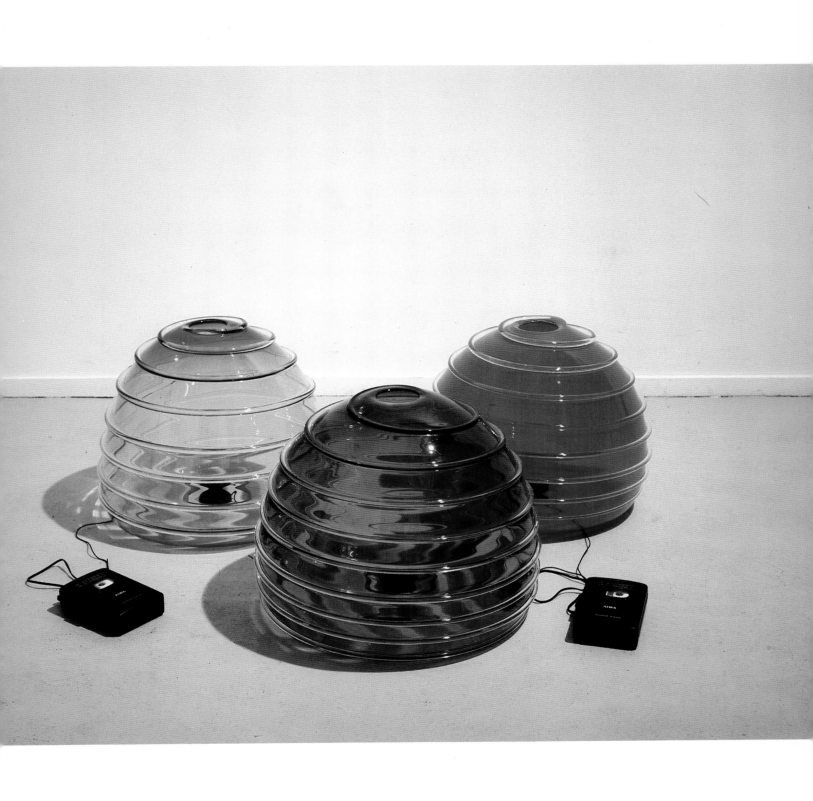

Judy Pfaff

Born in 1946 in London
Lives in New York

1973 M.F.A., Yale University, New Haven
1971 B.F.A., Washington University, St. Louis
1968 Southern Illinois University,
Edwardsville
1965 Wayne State University, Detroit

**I tackled what I thought was sculpture just
by opening up the language for myself as
far and as wide as I could in terms of
materials, colors and references; I tried to
include all the things that were permissible
for painting, but absent in sculpture. So
the first pieces I made had huge titles,
taking in whole histories or archeolo-
gies. . . . I don't know what this penchant is
for making a whole cosmos, but it's
certainly there for me. . . . I want the lati-
tude of shifting thoughts in regard to
materials, colors and references. I can't be
bound by how they "should" relate to one
another. By going after a certain speed
traditionally reserved for painters, I'm
reaching for a crossing over of ideas and
a weaving of thinking and making.**
Judy Pfaff, "Sculptors' Interviews," *Art in
America,* November 1985, p. 131

Works in exhibition:

Milagro, 1991
Glass, wire, and aluminum
78 x 102 x 60 in.
Courtesy of the artist and
Max Protetch Gallery
Illustrated

3/4 Time, 1990
Mixed media
84 x 109 x 48 in.
Courtesy of the artist and
Max Protetch Gallery

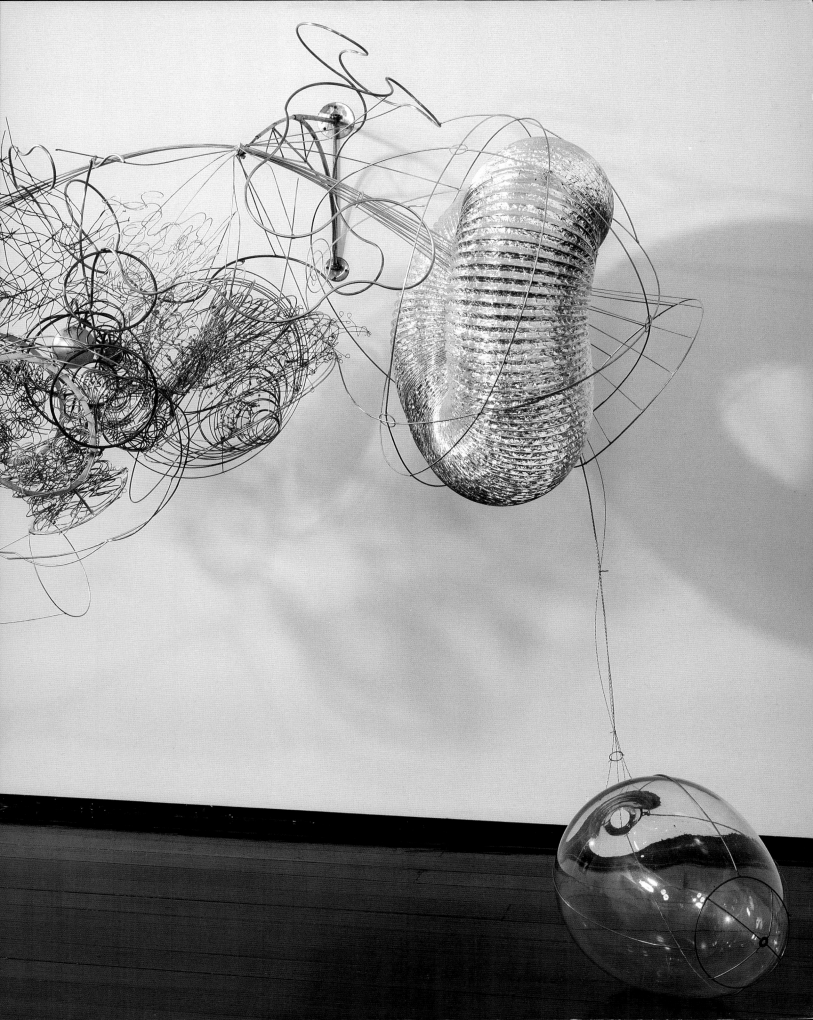

Susan Plum

Born in 1944 in Houston;
resident of Mexico City 1944—65
Lives in Seattle

1988 Pratt Fine Arts Center, Seattle
1986—87 Pilchuck Glass School, Stanwood,
Washington
1985—86 Pratt Fine Arts Center, Seattle
1963—64 University of the Americas,
Mexico City
1962—63 University of Arizona, Tucson

**These pieces are a part of a body of work
relating to sound. It is my translation of
sound, a primal force, in a contemporary
cosmology. According to Tantric philoso-
phy, sound and form are interdependent.
In this sense glass is used as an element,
the material, to describe motion or over-
tones, or to represent a state or condition.**

 ***Fa: Instrumento de Orden* is named
using the 12th-century Latin translation
for the musical note *Fa* or *Fata,* which
means planetary net. *Instruere* is instru-
ment, creator of order. *Nada: Voz de
Silencio* refers to the Sanskrit *nada,* "all
sound before it is perceived," and the
Spanish *nada,* meaning "nothing."**
Plum, written statement, 1991

Works in exhibition:

Nada: Voz de Silencio, 1990
Metal, glass, and silk-screened porcelain
enamel
51 x 19 x 13 in.
Courtesy of the artist
Illustrated

Fa: Instrumento de Orden, 1990
Metal, glass, and silk-screened porcelain
enamel
53 x 15 x 12 in.
Courtesy of the artist

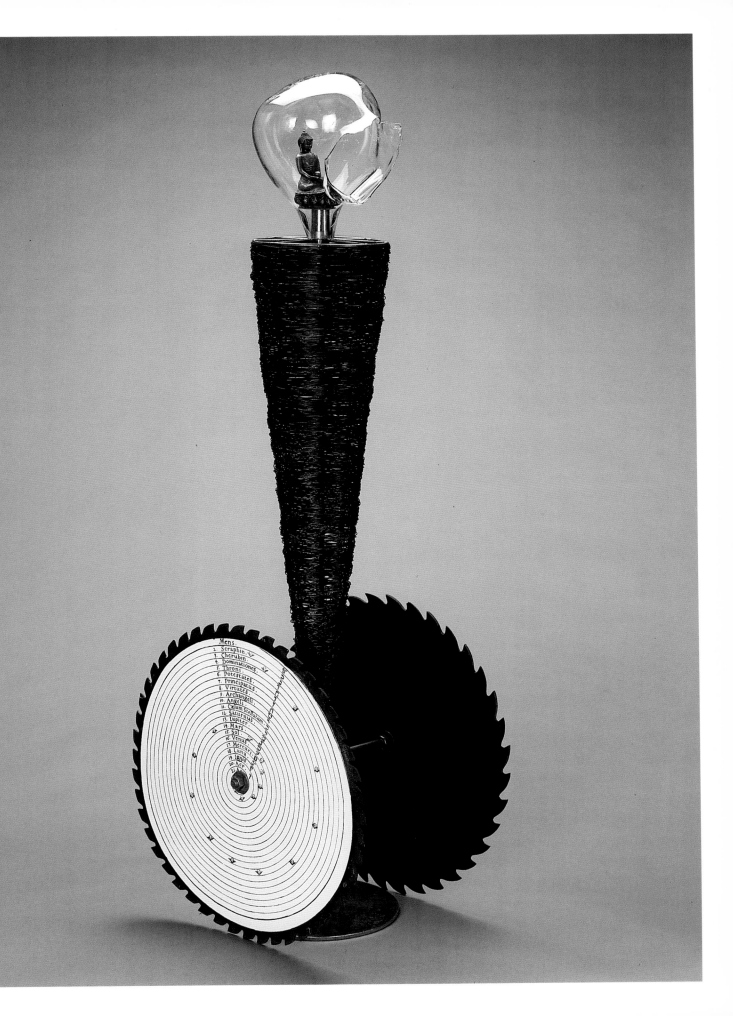

Jill Reynolds

Born in 1956 in Chicago
Lives in Seattle

1979 B.A., Evergreen State College, Olympia,
Washington
1974—75 Reed College, Portland, Oregon

**Jill Reynolds is one of the younger Seattle
artists who is helping to save glass art from
itself. Well-regarded for her spindly,
spider-web drawings and monotypes, she
broke into glass after being an artist-in-
residence at Pilchuck Glass School [in fall,
1990].**

**Glass for her is just another means of
drawing in space. She made loose, fragile,
clear glass letters of the alphabet and
suspended them against a black board in a
wavering, 8-foot high funnel titled "Holy
Spirit". . . . Reynolds is working with an
idea from the New Testament, that Christ
is the "Word made Flesh." Her letters,
these elements of language, are molten-
looking and mute, liquid-light and insub-
stantial, pouring themselves against a dark
ground.**
Regina Hackett, "Visual Feast Comes in Many
Forms," *Seattle Post-Intelligencer*, April 15, 1991,
p. D5

Works in exhibition:

Holy Spirit, 1991
Glass and wood
96 x 48 x 5 in.
Courtesy of the artist
Illustrated

Metaphor, 1990
Glass, gut, paper, beeswax, microcrystalline
wax, and clay
6 pieces, each 12 x 7 x 7 in.
Courtesy of the artist

The Experience of YES, 1990
Glass, and graphite on paper
34 x 64 x 3 in. overall
Courtesy of the artist

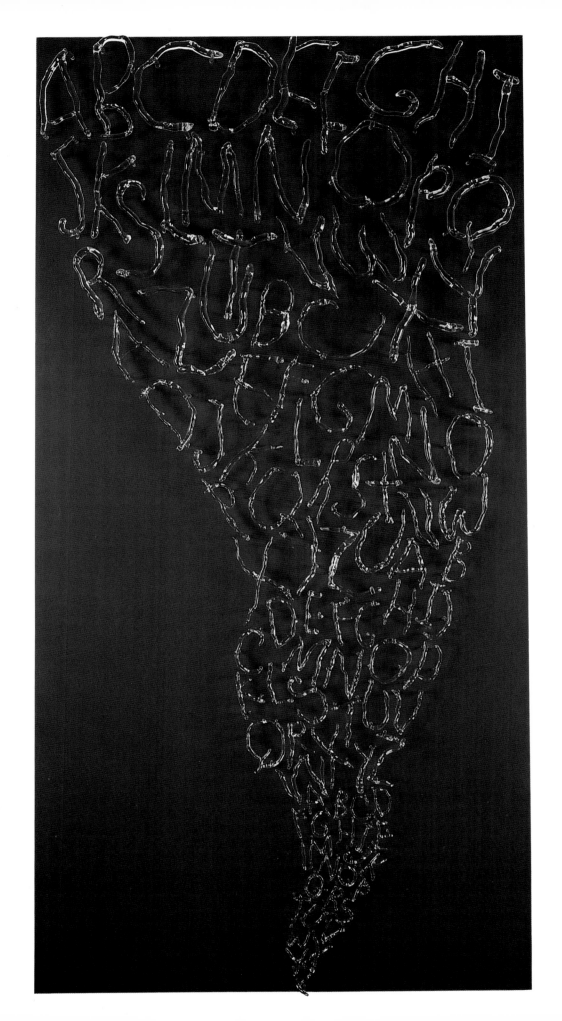

Norie Sato

Born in 1949 in Sendai, Japan
Lives in Seattle

1974 M.F.A., University of Washington, Seattle
1971 B.F.A., University of Michigan, Ann Arbor

The Birth of Momotaro is based upon two birth myths, one of western European origin, the other of Japanese; one is female, the other is male. The western myth is based on the *Birth of Venus* painting by Botticelli. A woman, born fully grown on a clamshell from the sea, is an idealized female image: beautiful, unblemished, pure. The other birth is based on a Japanese fairy story, "Momotaro" or Peach Boy. In this story, a childless older couple discover a baby boy inside a peach found in the mountains. The boy grows up to be brave, strong, and good, killing the dragons that threaten the villagers. He is a source of much pleasure and pride for the couple, an idealized male.

The installation combines the birth stories focusing not on the personae of the boy/male and woman/female, but on the circumstances of the birth stories themselves. Instead, the human presence is depicted in a non-gender-specific image of a human fetus via an ultrasound image. The monitor is sitting in a nest of glass triangles, beautiful and dangerous at the same time.

Sato, written statement, 1991

Work in exhibition:

Birth of Momotaro, 1990
Glass, video monitor, video, speakers, sand, plastic shell, and peach
Approximately 27 in. x 6 x 6 ft. (variable)
Courtesy of the artist and Linda Farris Gallery
Illustrated

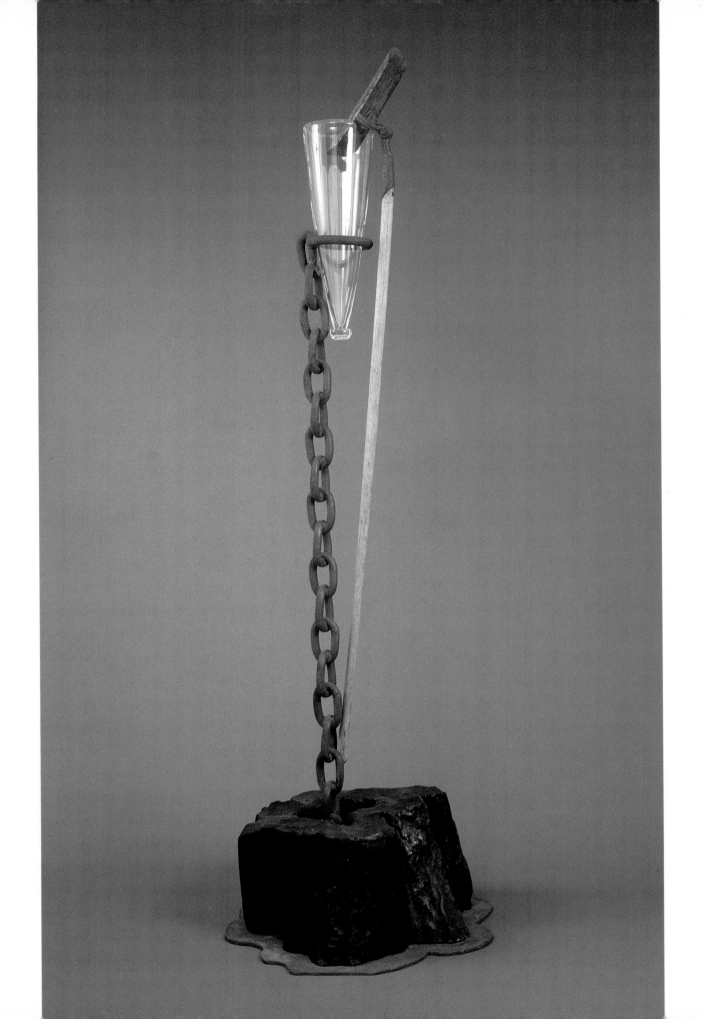

Joyce J. Scott

Born in 1948 in Baltimore
Lives in Baltimore

1971 M.F.A., Instituto Allende, San Miguel
Allende, Mexico
1970 B.F.A., Maryland Institute College of Art,
Baltimore

Like many of her generation, [Scott] is a transitional figure between tradition and the avant-garde. Her mother, Elizabeth Scott, and her grandmother are African-influenced quilters. Scott herself makes eccentric sewn and beaded assemblages as well as performances. "Generations tearing through stitching and hitching their dreams to untamed stars have coalesced in me. I accepted that challenge," she says. Scott's small figures — a "yellow" woman giving birth to a "brown" baby in *Birthing Chair*, or *Upside Down*, a lynching reversal — parallel her weaving, her fiber art, and her sculpture/jewelry, which is unlike any other "wearable art" in its fusion of a wry and nasty political humor with opulent materials. Scott insists on taking on the biggest issues in the smallest scale and most intimate materials.

Lucy R. Lippard, *Mixed Blessings: New Art in a Multicultural America,* New York: Pantheon Books, 1990, p. 74

Works in exhibition:

Catch a Nigger by His Toe, 1986
Glass beads, wire, thread, and cloth
14 x 12 x 8 in.
Collection of Oletha DeVane
Illustrated

Abstract, 1986
Mixed media
12 x 10 x 2 in.
Courtesy of the artist

No Mommy Me, from **Nanny Series,** 1991
Glass beads, leather, thread, and cloth
20 x 8 x 8 in.
Courtesy of the artist

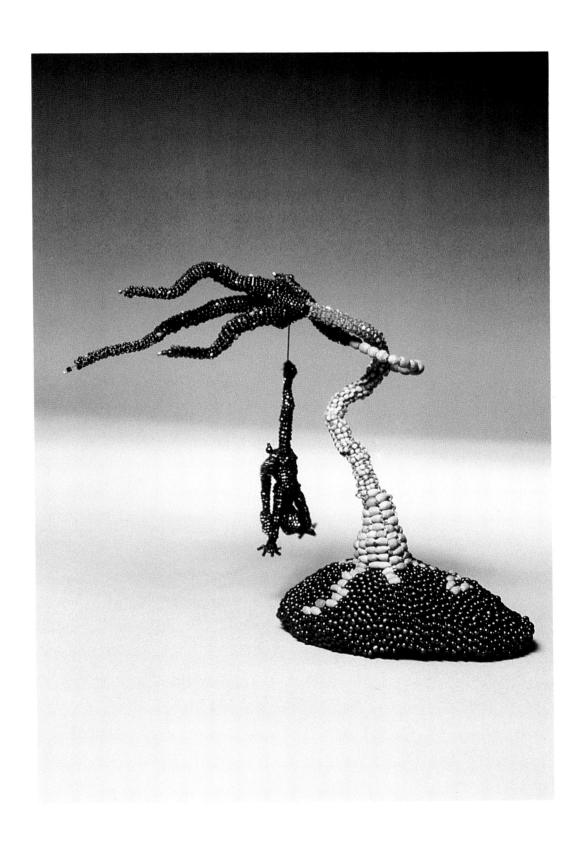

Buster Simpson

Born in 1942 in Saginaw, Michigan
Lives in Seattle

1969 M.F.A., University of Michigan, Ann Arbor
1966 B.S., University of Michigan, Ann Arbor
1961—64 Flint Junior College, Michigan

In 1982-83, I installed the *Crowbar Bottle Trap* in a dead-end alley in downtown Seattle, a site scheduled for redevelopment. Six crow windvanes were cantilevered atop 4-foot (crow)bars. The wrecking bar claws were hooked over a cable, allowing crows and crowbars to swing in the wind with the kind of body movement a crow makes when it caws. Below them, a mesh funnel emptied into a 55-gallon drum.

Here the public passed by, and street people congregated to "network" with their bottles of fortfied wine. The piece looked and worked like an arcade game — take the "dead soldier" (empty wine bottle) and try to hit the crow. Since wine and the sacred bird don't mix, I hoped perhaps some of the players' angst would be deposited in the recycling barrel. The accumulated barrels of glass bottle cullet were sold, and the proceeds given to the community clinic.

The fish-lure windvanes evolved in a series of runs beginning in 1978, when I installed a school of them at the Love Canal, New York, environmental disaster, where blue pike vanes hung over the Niagara River at a toxic landfill. Since then, I've installed schools of fish wind-vanes throughout North America. The lures draw attention to environmental concerns, such as a sewer outfall, or a stream sterilized by acid rain or choked by silt.

The ghost steelhead in this exhibition represent fish threatened by deterioration of the environment and competition for water diverted for electrical power and irrigation. On a long line, they "swim" as they do in the ocean. The shorter the line, the more rapid their movement, as if working their way upstream. Funds from the sales of these windvanes support my environmental projects.

Simpson, written statement, 1991

Illustration:

Crowbar Bottle Trap, installation in Seattle, 1982—83; view from Post Alley looking toward installation in adjacent alley.
Inset: view looking down on pedestrian-participants

Work in exhibition:

Crow Bars and Fish Lures, 1991
Steel, aluminum, glass, tar, and paint
Each fish 30 x 8 x 1½ in.
Courtesy of the artist

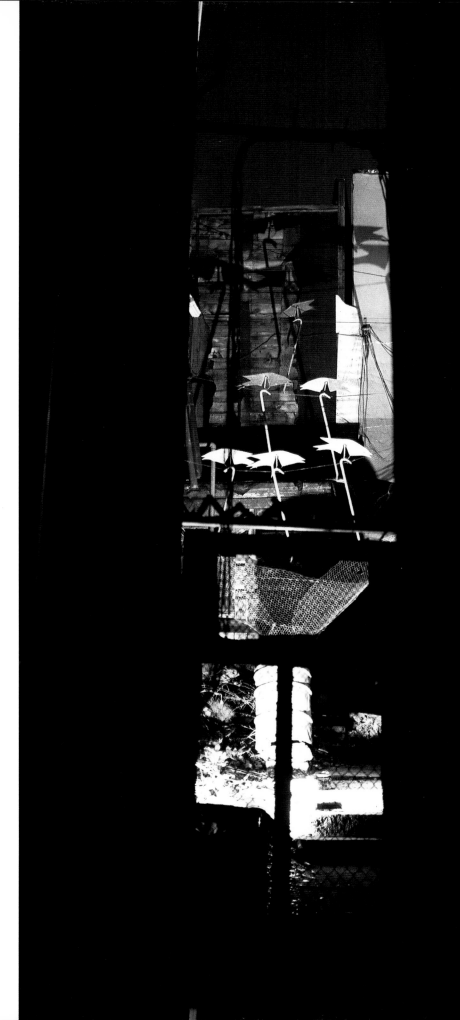

Kiki Smith

Born in 1954 in Nuremberg, Germany
Lives in New York

I wanted the installation [*Concentrations 20: Kiki Smith* at the Dallas Museum of Art, 1991] to be like a journey I use the body because it is our primary vehicle for experiencing our lives. It's something everyone shares, and there is no hierarchy; it doesn't distinguish between class or race.

Smith, quoted in Janet Kutner, "Free Association with the Human Body," *Dallas Morning News*, January 19, 1989, p. 4C

Work in exhibition:

Cross Section of a Head, 1989
Enamel on glass, fired
4 x 8 ft. (variable)
Courtesy of Fawbush Gallery
Illustrated

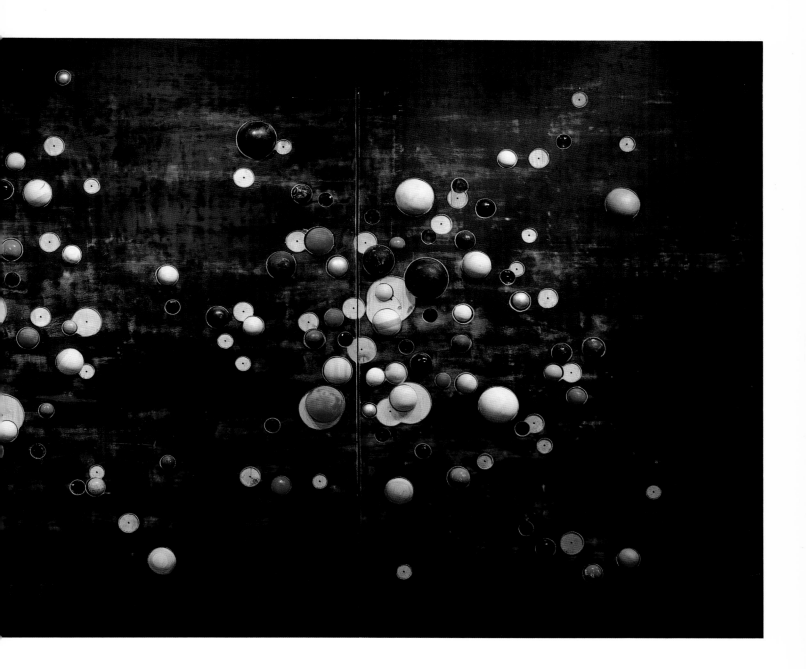

Bibliography and Artists' Resumes

General Bibliography

Barry, Brigit, comp. *Glass: Sources of Information on the History, Science, Technology, and Art of This Remarkable Material.* London: British Broadcasting Corporation, 1985

Chambers, Karen S. *Transparent Motives: Glass on a Large Scale.* Cincinnati: The Contemporary Arts Center, 1986

Corning Museum of Glass. *Glass 1959: A Special Exhibition of International Contemporary Glass.* Corning, New York, 1959

_____. *Contemporary Glass 1976-1978.* 3 vols. Corning, New York, 1976-1978

_____. *New Glass: A Worldwide Survey.* Corning, New York, 1979

_____. *New Glass Review 1-11.* 11 vols. Corning, New York, 1980-1990

Den Permanente. *Moderne skulptur i glas fra Tjekkoslovakiet.* Copenhagen, 1984

D'Harnoncourt, Anne, and Kynaston McShine, eds. *Marcel Duchamp.* New York: Museum of Modern Art, in association with Philadelphia Museum of Art, 1973

Emmet, Peter. *Art Works Glass: An Exhibition about Glass, and the Meaning of Materials.* Sydney: Crafts Councils Centre Gallery, 1985

Frantz, Susanne K. *Contemporary Glass: A World Survey from the Corning Museum of Glass.* New York: Abrams, 1989

Fucina degli Angeli. *Sculpture in Glass of the Fucina degli Angeli.* Venice: Adria Art, 1968

Glass Now 1982-1987. 6 vols. Takako Sano and Yamaha, 1982-1987

Marcel Duchamp: Notes and Projects for The Large Glass. Arranged and introduction by Arturo Schwarz. New York: Abrams, 1969

Musée des Arts Décoratifs de la Ville Lausanne. *Expressions en verre: 200 sculptures contemporaines, Europe, USA, Japan; Collection du Musée des Arts Décoratifs.* Lausanne, 1986

Musée des Beaux-Arts. *Art du verre: Actualité internationale.* Rouen, 1985

Paz, Octavio. *Marcel Duchamp: Appearance Stripped Bare.* Translated by Rachel Phillips and Donald Gardner. Reprint. New York: Seaver Books, 1981

Nancy Bowen

Selected Solo Exhibitions

1991
Betsy Rosenfield Gallery, Chicago

1990
Annina Nosei Gallery, New York

1987
The Female Form as Muse, Zilka Gallery, Wesleyan University, Middletown, Connecticut

1983
Susan Caldwell Gallery, New York

1981
Galerie Farideh Cadot, Paris

Selected Group Exhibitions

1990
Fragments, Parts, Wholes: The Body in Culture, White Columns, New York

1989
Sculpture '89, University Art Gallery, State University of New York, Albany

1988
The Politics of Gender, Queensborough Community College Gallery, New York

1987
In Pieces: The Figure Fragmented, P.S. 122 Gallery, New York

1986
Drawing Down the Moon, Cultural Center 1199, New York

Body & Soul: Recent Figurative Sculpture, The Contemporary Arts Center, Cincinnati. Traveling exhibition

The Figure Renewed, Freedman Gallery, Albright College, Reading, Pennsylvania

1984
Activated Walls, The Queens Museum of Art, New York

1983
Sculpture Now: Recent Figurative Works, Institute for Contemporary Arts, Virginia Museum, Richmond

1982
Narrative Sculpture, Sculpture Center, New York

1981
Chicago Artists, Centre d'Art Contemporain, Geneva

Relief(s): Bowen, Hazlitt, Tuttle, L'Institut Franco-Americain, Rennes, France

1980
Discovery/Rediscovery, Sculpture Center, New York

Awards

1990
Phillip Morris Fellowship, Yaddo Colony, Saratoga Springs, New York

Visiting Artist, Pilchuck Glass School, Stanwood, Washington

1989

Fellowship, New York Foundation for the Arts

Visiting Artist, American Academy in Rome

Visiting Artist, Centre International de Recherche sur le Verre et les Arts Plastiques (C.I.R.V.A.), Marseilles

1986

Award, Art Matters, Inc., New York

Bibliography

Brenson, Michael. "Figurative Sculpture in the Eighties." *The New York Times*, June 13, 1989

Johnson, Ken. "Nancy Bowen at Annina Nosei." *Art in America*, October 1990

Kirshner, Judith. "Nancy Bowen at Betsy Rosenfield Gallery." *Artforum*, April 1991

Rogers-Lafferty, Sarah. *Body and Soul: Aspects of Recent Figurative Sculpture.* Cincinnati: The Contemporary Arts Center, 1985

Rosenblum, Richard. *Narrative Sculpture.* Columbus Museum of Art, 1981

Sheppard, Ileen. *Activated Walls.* New York: The Queens Museum, 1984

Tannenbaum, Judith. *The Figure Renewed.* Reading, Pennsylvania: Freedman Gallery, Albright College, 1985

Mark Calderon

Selected Solo Exhibitions

1991

Sculpture, Spokane Center Gallery at Eastern Washington University

Greg Kucera Gallery, Seattle

1990

Jamison/Thomas Gallery, New York

1987

Documents Northwest: Mark Calderon, Seattle Art Museum

Selected Group Exhibitions

1991

Big Objects, Tacoma Art Museum

1990

Contemporary West Coast Sculpture, Jamison/Thomas Gallery, Portland, Oregon

1989

Northwest Annual, Center on Contemporary Art, Seattle

1988

Betty Bowen Memorial Award Tenth Anniversary Exhibition, Seattle Art Museum

1987

Painting and Sculpture '87, Tacoma Art Museum

1986

New Sites/New Work, San Jose Institute of Contemporary Art, California

Awards

1989

Centrum Centennial Project, Residence Award at Walla Walla Foundry, Washington

Seattle Artists 1989 Project, Seattle Arts Commission

Sculpture Award, Pacific Northwest Arts Exhibition, Bellevue, Washington; also 1988

Award, Art Matters, Inc., New York

1987

Lester S. Baskin Memorial Award, Tacoma Art Museum

1986

Betty Bowen Memorial Award, Seattle Art Museum

Bibliography

Berger, David. *Documents Northwest: Mark Calderon.* Seattle Art Museum, 1987

Carlsson, Jae. "Mark Calderon, Jamison/Thomas Gallery." *Artforum*, January 1990

Glowen, Ron. "Modernism and Symbolism." *Artweek*, June 27, 1987

Pincus, Robert. "Minimalist View Represented in Calderon Piece." *San Diego Union*, August 6, 1988

Smallwood, Lyn. "New Reviews." *Seattle Weekly*, March 27, 1991

Mel Chin

Selected Solo Exhibitions

1990

Viewpoints: Mel Chin, Walker Art Center, Minneapolis. Traveling exhibition

1989

Directions: Mel Chin, Hirshhorn Museum and Sculpture Garden, Washington, D.C.

1988

Selected Weapons, Frumkin/Adams Gallery, New York

1987

The Operation of the Sun Through the Cult of the Hand, Loughelton Gallery, New York

1985

Modus Operandi 1974-1985, Diverse Works, Houston

1979

The Waterwheel/Keeping Still (the Great Wheel of China), Art Gallery, University of Houston at Clearlake

Selected Group Exhibitions

1990

This Land. The State of Texas: An Earth Event, Lawndale Art and Performance Center, Houston

Mel Chin, Eric Levine, Manuel Neri, B.R. Kornblatt Gallery, Washington, D.C.

1989

Noah's Art, City Parks Department, Central Park, New York

China - June 4, 1989, BlumHelman Warehouse, New York. Traveling exhibition

1988

Public Art in Chinatown, Asian American Arts Center, New York

1986

The Texas Landscape: 1900-1986, Museum of Fine Arts, Houston

1983

Showdown: Perspective on the Southwest, Alternative Museum, New York

1979

Fire! An Exhibition of 100 Texas Contemporary Artists, Contemporary Arts Museum, Houston

1978

Young Americans: Clay/Glass, Tucson Museum of Art, Arizona. Traveling exhibition

Bibliography

Boswell, Peter W. *Viewpoints: Mel Chin.* Minneapolis: Walker Art Center, 1990

Henry, Gerrit. "Mel Chin: Surveying Heaven and Earth." *Sculpture*, January/February 1991

Johnson, Patricia. "True to Form: Houston-Born Mel Chin Addresses Power and Politics in Three New Sculptures." *Houston Chronicle*, April 16, 1989

Levin, Kim. "Eco-Offensive Art." *Village Voice*, January 1, 1991

Lippard, Lucy R. *Mixed Blessings: New Art in a Multicultural America.* New York: Pantheon, 1990

Riddle, Mason. "Mel Chin." *Arts Magazine*, February 1991

Rifkin, Ned. *Directions: Mel Chin.* Washington, D.C.: Hirshhorn Museum and Sculpture Garden, 1989

Saussy, Haun. *Mel Chin: The Operation of the Sun Through the Cult of the Hand.* New York: Loughelton Gallery, 1987

Yau, John. *Diverse Representations.* Morristown, New Jersey: Morris Museum, 1990

_____ . *To Propose, To Provoke.* New York: Public Art in Chinatown, 1988

Houston Conwill, Joseph De Pace, and Estella Conwill Majozo (Collaborative Projects)

Solo (Collaborative) Exhibitions

1989
Houston Conwill: WORKS, Hirshhorn Museum and Sculpture Garden, Washington, D.C.

Cakewalk Humanifesto: A Cultural Libation, Museum of Modern Art, New York

1988
Art at the Edge: Houston Conwill, High Museum of Art, Atlanta. Traveling exhibition

Selected Group Exhibitions

1991
Places with a Past: New Site-Specific Art in Charleston, Spoleto Festival USA, Charleston, South Carolina

1990
The Decade Show, Museum of Contemporary Hispanic Art, Studio Museum in Harlem, and The New Museum of Contemporary Art, New York

Prophets and Translators, The Chrysler Museum, Norfolk, Virginia

1989
Contemporary African American Artists, Williams College Art Museum, Williamstown, Massachusetts

Revelations, Aspen Museum of Art, Colorado

1988
Acts of Faith: Politics and the Spirit, Cleveland State University Gallery, Ohio

Performances

1989
Cakewalk Humanifesto: A Cultural Libation, Museum of Modern Art, New York

1987
Purgatory, The Kentucky Theatre, Louisville

Public Commissions

1991
Rocky Mount, North Carolina

Du Sable's Journey, Harold Washington Library, Chicago

Martin Luther King, Jr., Memorial, Yerba Buena Gardens, San Francisco

1990
The Blues Madonna, Filmore Center, San Francisco

Rivers, Langston Hughes Auditorium, Schomburg Center for Research in Black Culture, The New York Public Library

1988
Dallas Zoo Project

1986
Poets' Rise, Social Security Building, Jamaica, New York

Bibliography

Bontemps, Jacqueline Fouvielle. *Choosing: An Exhibit of Changing Perspectives in Modern Art and Art Criticism 1925-1985*. Washington, D.C.: Museum Press, 1986

Campbell, Mary Schmidt. *Tradition and Conflict: Images of a Turbulent Decade 1963-1973.* New York: Studio Museum in Harlem, 1985

Jacob, Mary Jane. *Places with a Past: New Site-Specific Art in Charleston.* New York: Spoleto Festival USA and Rizzoli International (forthcoming 1992)

Krane, Susan. *Art at the Edge: Houston Conwill, The New Cakewalk.* Atlanta: High Museum of Art, 1989

Lawrence, Sidney. *Houston Conwill: WORKS.* Washington, D.C.: Hirshhorn Museum and Sculpture Garden, 1989

Lippard, Lucy R. *Mixed Blessings: New Art in a Multicultural America.* New York: Pantheon Books, 1990

_____ . *Overlay: Contemporary Art and the Art of Prehistory.* New York: Pantheon Books, 1983

Sims, Lowry Stokes, Sharon F. Patton, and Judith Wilson. *The Decade Show*, New York: Museum of Contemporary Hispanic Art, Studio Museum in Harlem, and The New Museum of Contemporary Art, 1990

Zelevansky, Lynn. *Cakewalk Humanifesto.* New York: Museum of Modern Art, 1989

Houston Conwill

Awards

1990
Honorary Doctorate of Humane Letters, Niagara University

Distinguished Alumnus, Howard University

1989
Fellowship, National Endowment for the Arts; also 1982

1987
Fellowship, Louis Comfort Tiffany Foundation

1985
Fellowship, New York Foundation for the Arts

1984
Prix de Rome, American Academy in Rome

1982
Fellowship, John Simon Guggenheim Memorial Foundation

Ebonics Outstanding Alumnus, University of Southern California

Joseph De Pace

Awards

1989
Project Entry, Design Competition, Clemson University Performing Arts Center, Clemson, South Carolina

1986
Project Entry, Design Competition, Gandhi National Cultural Center, New Delhi

1985
Project Entry, Design Competition, *Biennale*, Venice

1984
Steedman Fellow in Architecture, American Academy in Rome

1978
Del Gaudio Award, New York Society of Architects

Estella Conwill Majozo

Publications

(Estella Conwill Majozo has published under various names.)

"The Call/Response" and "Gwendolyn Was Here/Is" in *Say That the River Turns*. Third World Press, 1987

"Contradictions in Black Life: Recognized and Reconciled in How I Got Ovah." *CLA Journal* XXV, No. 1

Darkness Knows. Lake MacBride, Iowa: Macaenas Press, 1979

Love Songs and New Spirituals. Edited with Frederick Woodard. Iowa City: University of Iowa, 1980

Metamorphosis. Louisville: Bruce Press, 1975

True Poems. Edited with Frederick Woodard. Iowa City: University of Iowa, 1978

Judy Pfaff

Selected Solo Exhibitions

1990
Judy Pfaff: Sculpture and Works on Paper, Cleveland Center for Contemporary Art

Judy Pfaff/Equinox, Max Protetch Gallery, New York

1989
Currents 41: Judy Pfaff, Saint Louis Art Museum

1988
Carnegie Mellon University Art Gallery, Pittsburgh

Forefront: Judy Pfaff, National Museum of Women in the Arts, Washington, D.C.

1986
Apples and Oranges, Holly Solomon Gallery, New York

1984
Celebration, Spokane City Hall, Washington

1982
Rock/Paper/Scissors, Albright-Knox Art Gallery, Buffalo, New York

1981
Judy Pfaff: Installations, Collages, and Drawings, John and Mable Ringling Museum of Art, Sarasota, Florida. Traveling exhibition

1978
Artists Space, New York

Prototypes, LACE (Los Angeles Contemporary Exhibitions)

Selected Group Exhibitions

1990
Seoul International Art Festival: Works on Mulberry Paper, National Museum of Contemporary Art, Seoul, South Korea

Diverse Representations, Morris Museum, Morristown, New Jersey

1989
Making Their Mark, Cincinnati Art Museum. Traveling exhibition

Contemporary Environment, Museum of Modern Art, New York

1987
Biennial Exhibition, Whitney Museum of American Art, New York; also 1981, 1975

Standing Ground: Sculpture by American Women, The Contemporary Arts Center, Cincinnati

Faux Arts: Surface Illusions and Simulated Materials in Recent Art, La Jolla Museum of Contemporary Art, California

1985
Vernacular Abstraction, Wacoal Art Center, Tokyo

Working in Brooklyn: Sculpture, Brooklyn Museum

An American Renaissance: Painting and Sculpture Since 1940, Museum of Art, Fort Lauderdale, Florida

1984
Out of Square, Cranbrook Academy of Art Museum, Bloomfield Hills, Michigan

An International Survey of Recent Painting and Sculpture, Museum of Modern Art, New York

Biennale XLI, Venice; also 1982

A Decade of New Art, Artists Space, New York

1983
The Sixth Day: A Survey of Recent Developments in Figurative Sculpture, The Renaissance Society, University of Chicago

Back to the USA, Kunstmuseum Luzern, Switzerland. Traveling exhibition

New Art, Tate Gallery, London

1982
New York Now, Kestner-Gesellschaft, Hannover, West Germany. Traveling exhibition

1981
Directions 1981, Hirschhorn Museum and Sculpture Garden, Washington, D.C.

Zeitgenossische Kunst seit 1939, Museen der Stadt Köln, Cologne, West Germany

Body Language: Figurative Aspects of Recent Art, Hayden Gallery, Massachusetts Institute of Technology, Cambridge. Traveling exhibition

Post-Modernist Metaphors, The Alternative Museum, New York

1980
Extensions: Jennifer Bartlett, Lynda Benglis, Robert Longo, Judy Pfaff, Contemporary Arts Museum, Houston

Watercolors, Institute for Contemporary Art, P.S. 1 Museum, Long Island City, New York

Awards

1986
Fellowship, National Endowment for the Arts; also 1979

1984
Bessie Award, Set Design for Nine Weiner Company at Brookyn Academy of Music

1983
Fellowship, John Simon Guggenheim Memorial Foundation

1976
Creative Arts Public Services Program, New York

Bibliography

Armstrong, Richard. "Judy Pfaff." *LAICA Journal/Art Rite*, Summer 1978

Arnason, H.H. *History of Modern Art*. New York: Abrams, 1986

King, Elaine A. *Judy Pfaff*. Pittsburgh: Carnegie Mellon University, 1988

Radcliff, Carter. "Portrait of the Artist as a Survivor." *New York Magazine*, November 27, 1978

Saunders, Wade. "Talking Objects: Interviews With Ten Younger Sculptors." *Art in America*, November 1985

Tucker, Marcia. "An Iconography of Recent Figurative Painting: Sex, Death, Violence, and the Apocalypse." *Artforum*, September 1981

Yau, John. "Left-Right: A Project for Artforum by Judy Pfaff." *Artforum*, May 1990

Susan Plum

Selected Group Exhibitions

1991
The Frozen Moment: Contemporary Northwest Images in Glass, Bellevue Art Museum, Washington

World Glass Now '91, Hokaido Museum of Modern Art, Sapporo, Japan

1990
Objects of Our Affection, Fuller/Elwood Gallery, Seattle

A Goblet Show, Maurice Littleton Gallery, Washington, D.C.

1989
Northwest Annual, Center on Contemporary Art, Seattle

Glass Inventions, Silica Dreams: Three Pacific Northwest Artists, San Francisco Craft and Folk Art Museum

Bibliography

Corning Museum of Glass. *New Glass Review 11*. Corning, New York, 1990

Kasuga, Yochiko. "Art at Your Service," *Pronto*, 1990

Waggoner, Shawn. "Lampworking." *Glass Art*, December 1988

Weiss, Dick. "Northwest Letter." *Glasswork*, May 1990

Jill Reynolds

Selected Solo Exhibitions
1990
MVSEVM, Cliff Michel Gallery, Seattle

Selected Group Exhibitions
1991
Ten Eyes, Cliff Michel Gallery, Seattle

1990
Northwest Annual, Center on Contemporary Art, Seattle; also 1989

Organic Abstraction, Bumbershoot Festival, Seattle

1987
Painting and Sculpture '87, Tacoma Art Museum

Awards
1991
Artist in Residence, Pratt Fine Arts Center, Seattle

1990
Artist in Residence, Pilchuck Glass School, Stanwood, Washington

Centrum Foundation Printmaking Residency, Port Townsend, Washington

Best of Show, *Northwest Annual,* Center on Contemporary Art, Seattle

Bibliography
Bryant, Elizabeth. "New Reviews." *Reflex,* May/June, 1990

Glowen, Ron. "Reshaping Glass." *Artweek,* May 2, 1991

Gragg, Randy. "See 'em Now, See 'em Later." *The Oregonian,* August 24, 1990

Hackett, Regina. "Visual Feast Comes in Many Forms." *Seattle Post-Intelligencer,* April 15, 1991

Smallwood, Lyn. "New Reviews." *Seattle Weekly,* April 24, 1991

_____. "This Girl's Life." *Seattle Weekly,* April 18, 1990

Norie Sato

Selected Solo Exhibitions
1991
Norie Sato, Index Gallery, Clark College, Vancouver, Washington

1990
Transmission/Transition, Linda Farris Gallery, Seattle

1989
New Works in Paper and Glass, Elizabeth Leach Gallery, Portland, Oregon

1987
Incidents of Interference II, Reed College Art Gallery, Portland, Oregon

1984
Documents Northwest: Norie Sato, Virtual Imaging, Seattle Art Museum

Phosphor Theater: Interference Display, Vancouver Art Gallery, Canada

1982
Signal Interference III: An Interrupted Journey, Rainier Square Atrium, Seattle, sponsored by Seattle Arts Commission

1980
Whatcom Museum of History and Art, Bellingham, Washington

Selected Group Exhibitions
1991
The Frozen Moment: Contemporary Northwest Images in Glass, Bellevue Art Museum, Washington

1990
Official Language, San Francisco Art Institute

1988
Home Show, Santa Barbara Contemporary Arts Forum, California

1987
15th Avenue Studio II: The Mechanics of Contemplation, Henry Art Gallery, University of Washington, Seattle

1986
Outside Japan, Washington State University Museum of Art, Pullman

1984
Video: A Retrospective (Part II, West Coast Focus), Long Beach Museum of Art, California

1983
Impressions I: Experimental Prints, Institute of Contemporary Art, Virginia Museum of Fine Arts, Richmond. Traveling exhibition

1981
19 Artists - Emergent Americans, Solomon R. Guggenheim Museum, New York

1980
New York, Seattle, Los Angeles, organized by the Museum of Modern Art, New York. Traveling exhibition

1979
Projects: Video XXIV, Museum of Modern Art, New York

Lande/Ritchie/Sato, Vancouver Art Gallery, Canada

1976
30 Years of American Printmaking/20th National Print Exhibition, Brooklyn Museum

Public Commissions
1991
In Public: Seattle 1991, Seattle Arts Commission and Seattle Art Museum

Artists Design Team, Dallas Convention Center

1990
Artists Design Team, Denver International Airport

Awards
1989
Fellowship, Western States Regional Media Arts; also 1987, 1982

Fellowship, Washington State Arts Commission

1983
Betty Bowen Memorial Award, Seattle Art Museum

1981
Fellowship, National Endowment for the Arts; also 1979

1980
Art in Public Places Planning Grant, National Endowment for the Arts

1979
Grant, King County Arts Commission, Washington

Bibliography
Baro, Gene. *Thirty Years of American Printmaking.* Brooklyn Museum, 1977

Carlsson, Jae. "Reviews." *Artforum,* October 1989

"Dialogue: Norie Sato, Carl Chew and Bill Ritchie." *Visions,* Spring 1991

Failing, Patricia. *Documents Northwest: Norie Sato.* Seattle Art Museum, 1984

Italo Scanga

Selected Solo Exhibitions

1990

Italo Scanga, University Art Gallery, California State University, Chico

Italo Scanga, New Britain Museum of American Art, Connecticut

Italo Scanga, Missoula Museum of the Arts, Montana

Betsy Rosenfield Gallery, Chicago

1989

Dorothy Goldeen Gallery, Santa Monica, California

Germans van Eck Gallery, New York

1986

David Winton Bell Gallery, Brown University, Providence, Rhode Island. Traveling exhibition

Italo Scanga, 1972-1985, The Oakland Museum, California. Traveling exhibition

1985

Arte Contemporáneo, Mexico City

1984

Aspen Center for the Visual Arts, Colorado

1983

La Jolla Museum of Contemporary Art, California

Los Angeles County Museum of Art

1982

Neuberger Museum, State University of New York, Purchase

1978

Institute for Art and Urban Resources, The Clocktower, New York

1973

Fine Arts Gallery, University of Rhode Island, Kingston

1972

Whitney Museum of American Art, New York

1969

Baylor University Art Gallery, Waco, Texas

Selected Group Exhibitions

1988

Three Italo-American Artists: Giorgio Cavallon, Costantino Nivola, and Italo Scanga, Peggy Guggenheim Collection, Palazzo Venier dei Leoni, Venice

Mary Beth Edelson, Martin Puryear, Italo Scanga, Robert Stackhouse, Corcoran Gallery of Art, Washington, D.C.

1987

The Eloquent Object, Philbrook Museum of Art, Tulsa, Oklahoma. Traveling exhibition

1986

Other Gods: Containers of Belief, Everson Museum of Art, Syracuse, New York. Traveling exhibition

Sacred Images in Secular Art, Whitney Museum of American Art, New York

Momento Mori, Centro Cultural Arte Contemporáneo, Mexico City

Neues Glas aus Japan und Amerika, Gewerbemuseum Basel, Switzerland. Traveling exhibition

1985

Body and Soul: Aspects of Recent Figurative Sculpture, The Contemporary Arts Center, Cincinnati

1984

Assemblage, Institute for Contemporary Art, Center for Art and Urban Resources, P.S. 1 Museum, New York

An International Survey of Recent Painting and Sculpture, Museum of Modern Art, New York

Primitivism in 20th Century Art, Museum of Modern Art, New York

El Arte Narrativo, Museo Rufino Tamayo, Mexico City. Traveling exhibition

1983

Biennial Exhibition, Whitney Museum of American Art, New York

The Sixth Day: A Survey of Recent Developments in Figurative Sculpture, The Renaissance Society, University of Chicago

1982

Anxious Edge, Walker Art Center, Minneapolis

1980

Material Pleasures, Museum of Contemporary Art, Chicago

1978

Despair, Hallwalls, Albright-Knox Art Gallery, Buffalo, New York

1977

Carpenter, Chihuly, Scanga: The Pilchuck School, Seattle Art Museum

1971

Depth and Presence, Corcoran Gallery of Art, Washington, D.C.

Projects: Pier 18, Museum of Modern Art, New York

Awards

1989

Distinguished Alumnus Award, Michigan State University

1980

Fellowship, National Endowment for the Arts; also 1973

1972

Grant, James S. Copley Foundation

1965

First Prize in Sculpture, National Art Exhibition, New Bedford, Massachusetts

Bibliography

Everson Museum of Art. *Other Gods: Containers of Belief.* Syracuse, New York, 1986.

Flood, Richard. *El Arte Narrativo.* Mexico City: Museo Rufino Tamayo, 1984

_____. *The Sixth Day: A Survey of Recent Developments in Figurative Sculpture.* Chicago: The Renaissance Society, University of Chicago, 1983

Kardon, Janet. *Masks, Tents, Vessels, Talismans.* Philadelphia: Institute of Contemporary Art, University of Pennsylvania, 1979

Licht, Fred. *Three Italo-American Artists: Giorgio Cavallon, Costantino Nivola, Italo Scanga.* Milan: A. Mondadori, 1988

Livingston, Jane. *Mary Beth Edelson, Martin Puryear, Italo Scanga, Robert Stackhouse.* Washington D. C.: Corcoran Gallery of Art, 1988

Nahas, Dominique. *Figures: Form and Fictions.* Syracuse, New York: Everson Museum of Art, 1988

Nesbitt, Perry. *Enigmatic Inquiry: The Search for Meaning.* Greenville, North Carolina: Gray Art Gallery, East Carolina University, 1988

Whitney Museum of American Art. *Sacred Images in Secular Art.* New York, 1986

Joyce J. Scott

Selected Solo Exhibitions

1990

Washington County Museum of the Fine Arts, Hagerstown, Maryland

Joyce Scott, Alexandre Hogue Gallery, University of Tulsa, Oklahoma

Selected Group Exhibitions

1990

American Dreams, American Extremes, Kruithuis Museum, Hertogenbosch, Netherlands. Traveling exhibition

Surface and Structure: Beads in Contemporary American Art, Renwick Gallery, Smithsonian Institution, Washington, D.C.

(Not So) Simple Pleasures, List Visual Arts Center, Massachusetts Institute of Technology, Cambridge

Explorations: The Aesthetics of Excess, American Crafts Museum, New York. Traveling exhibition

Southern Black Aesthetic, Southeastern Center for Contemporary Art, Winston-Salem, North Carolina. Traveling exhibition

1989

Elizabeth T. Scott/Joyce J. Scott, Family Traditions/Recent Works, Pennsylvania Academy of the Fine Arts, Philadelphia

Stitching Memories: African American Story Quilts, Williams College Museum of Art, Williamstown, Massachusetts

Craft Today, USA, American Crafts Museum, New York. Traveling exhibition

1988

The Eloquent Object, Philbrook Museum of Art. Traveling exhibition

Beads, John Michael Kohler Arts Center, Sheboygan, Wisconsin

6th International Triennale of Tapestry, Lodz, Poland

1987

Tangents: Art in Fiber, Maryland Institute College of Art, Baltimore. Traveling exhibition

1986

Other Gods: Containers of Belief. Everson Museum of Art, Syracuse, New York. Traveling exhibition

1984

Linda Depalma and Joyce J. Scott, Baltimore Museum of Art

Arts of Adornment: Wearable Art from Africa and the Diaspora, Gallery Association of New York. Traveling exhibition

Three Generations of African American Quiltmakers: The Scott Caldwell Family, Fondo del Sol Visual Arts and Media, Washington, D.C.

1983

Ritual and Myth: A Celebration of African American Arts, Studio Museum in Harlem, New York

Exposure, Baltimore Museum of Art

1982

Surface/Structure: Fibre of African American Arts, Studio Museum in Harlem, New York

1981

Good as Gold, Renwick Gallery, Smithsonian Institution, Washington, D.C.

Something Got A Hold on Me, Washington Project for the Arts, Washington, D.C. Traveling exhibition

1978

Maryland Biennial, Baltimore Museum of Art; also 1976

Performances

1990
Honey Chil Milk

1989
Generic Interference, Genetic Engineering

1986
Women of Substance, performed by The Thunder Thigh Revue

Awards

1990
National Printmaking Fellowship, Rutgers Center for Innovative Printmaking, New Brunswick, New Jersey

1988
Fellowship, National Endowment for the Arts

1987
Artist in Residence, Pyramid Atlantic Grant and The Mid-Atlantic Art Consortium

1986
Fellowship, Maryland Arts Council; also 1982

Bibliography

Baltimore Museum of Art. *Montage of Dreams Deferred.* Baltimore, 1979

Bontemps, Jacqueline Fouvielle. *Choosing: An Exhibit of Changing Perspectives in Modern Art and Criticism by Black Americans 1925-1985.* Washington, D.C.: Museum Press, 1986

Herman, Lloyd. *Good as Gold.* Washington D. C.: Renwick Gallery, Smithsonian Institution, 1984

Lippard, Lucy R. *Mixed Blessings: New Art in a Multicultural America.* New York: Pantheon, 1990

Manhart, Marcia, and Tom Manhart, eds. *The Eloquent Object: The Evolution of American Art in Craft Media since 1945.* Tulsa, Oklahoma: Philbrook Museum of Art, 1987

Maryland Institute College of Art. *Tangents: Art in Fiber.* Baltimore, 1987

Studio Museum in Harlem. *Ritual and Myth: A Survey of African American Art.* New York, 1982

Buster Simpson

Selected Solo Exhibitions

1991
Documents Northwest: Buster Simpson, The Effluence of Affluence, Seattle Art Museum

1989
Buster Simpson: WORKS, Face Plate, Hirshhorn Museum and Sculpture Garden, Washington, D.C.

1988
Buster Simpson: West Sixth Streetscape, Spaces, Seattle

1985
Buster Simpson: From the Crystal Plumb, Portland Center for the Visual Arts, Oregon

1980
Buster Simpson, Western Front Gallery, Vancouver, Canada

Selected Group Exhibitions

1988
Images and Latitude, Paris. Traveling exhibition

1987
Art with Community, Institute for Contemporary Art, P.S. 1 Museum, Long Island City, New York

1983
Outside New York: Seattle, The New Museum of Contemporary Art, New York. Traveling exhibition

1979
Andrew Keating/ Buster Simpson, Seattle Art Museum

1978
Artpark, Lewiston, New York

Selected Public Projects

1991
In Public: Seattle, Seattle Arts Commission and Seattle Art Museum

Host Analog, Portland Convention Center, Oregon

1990-92
King Street Gardens, Alexandria, Virginia

Anaheim Center Redevelopment, California

1989
Seattle George Monument, Washington State Convention Center, Seattle

1988
Situations: Arts on the Line, Massachusetts Bay Transportation Authority, Boston

West 6 Streetscape/ Inventory on Willcall, Cleveland

1982
Ninety Pine Street, Seattle

1981
Breakwater Run, Edmonds, Washington

Living Beach, Duvall, Washington

Pier 90 Radar Lure, Seattle

1978
Viewland/ Hoffman Receiving Substation, Seattle

Awards

1991
Fellowship, National Endowment for the Arts; also 1981

1984
Urban Arboretum Project Grant, National Endowment for the Arts and Seattle Arts Commission

Bibliography

Artpark. *Artpark 1978.* Lewiston, New York, 1978

Berkson, Bill. "Seattle Sites." *Art in America*, July 1986

Glowen, Ron. "A Concern for the Enviroment." *Artweek*, March 9, 1985

Kangas, Matthew. "Andrew Keating/ Buster Simpson." *Vanguard*, September 1979

_____. "Buster Simpson at Western Front." *Art in America*, January 1982

Rifkin, Ned. *Buster Simpson: WORKS.* Washington, D.C.: Hirshhorn Museum and Sculpture Garden, 1989

_____. *Outside New York: Seattle.* New York: The New Museum of Contemporary Art, 1983

Simpson, Buster. "Art, History, and Public Space: Buster Simpson on Stewardship." Elizabeth Morton, ed. *Carolina Planning*, Spring 1989

Sims, Patterson. *Documents Northwest: Buster Simpson, The Effluence of Affluence.* Seattle Art Museum, 1991

Kiki Smith

Selected Solo Exhibitions

1991
Institute for Contemporary Art, Amsterdam. Traveling exhibition

1990
Projects: Kiki Smith, Museum of Modern Art, New York

Centre d'Art Contemporain, Geneva

The Institute for Contemporary Art, The Clocktower, New York

Fawbush Gallery, New York

1989
Center for the Arts, Wesleyan University, Middletown, Connecticut

Concentrations 20: Kiki Smith, Dallas Museum of Art

1982
Life Wants to Live, The Kitchen, New York

Selected Group Exhibitions

1990
Figuring the Body, Museum of Fine Arts, Boston

Group Material: AIDS Timeline, Wadsworth Atheneum, Hartford, Connecticut

Diagnosis, Art Gallery of York University, Toronto

Witness Against Our Vanishing, Artists Space, New York

Fragments, Parts, and Wholes, White Columns, New York

1989
Projects and Portfolios, Brooklyn Museum

New York Experimental Glass, Society for Art in Craft, Pittsburgh

1988
Desire Path, Schulman Sculpture Garden, White Plains, New York

Committed to Print, Museum of Modern Art, New York

1986
Donald Lipski, Matt Mullican, Kiki Smith, Institute for Art and Urban Resources, The Clocktower, New York

Momento Mori, Centro Cultural Arte, Polanco, Mexico

1985
Synaesthetics, Institute for Contemporary Art, P.S. 1 Museum, Long Island City, New York

Moderna Museet, Stockholm

1984
Modern Masks, Whitney Museum of American Art, New York

1983
Island of Negative Utopia, The Kitchen, New York

1982
Documenta VII, Kassel, West Germany

1981
New York, New Wave, Institute for Contemporary Art, P.S. 1 Museum, Long Island City, New York

Lightning, Institute for Contemporary Art, P.S. 1 Museum, Long Island City, New York

Bibliography

Ahearn, Charles. "Kiki Smith." *Interview*, December 1990

Chambers, Karen. *New York Experimental Glass.* Pittsburgh Society for Arts in Crafts, 1989

Faust, Wolfgang Max. "Emotope—A Project for Buro Berlin." *Artforum*, January 1988

Hayt Atkins, Elizabeth. "Envisioning the Yesterday of Tomorrow and the Tomorrow of Today." *Contemporanea*, January 1991

Institute of Contemporary Art, Amsterdam. *Kiki Smith.* Amsterdam, and SDU Publishers, The Hague, 1991.

Lyons, Chris. "Kiki Smith: Body and Soul." *Artforum*, February 1990

Princenthal, Nancy. "Life Wants to Live, The Kitchen." *ArtNews*, April 1984

Smith, Kiki. "Berlin, Los Angeles, New York." *BOMB*, 1983

John Torreano

Selected Solo Exhibitions

1991
Dart Gallery, Chicago

Shea and Beker Gallery, New York

Susanne Hilberry Gallery, Birmingham, Michigan

1989
John Torreano: Natural Models and Material Illusions, Corcoran Gallery of Art, Washington, D.C. Traveling exhibition

1988
John Torreano: Gems, Stars, and Perceptual Trackings, Grand Rapids Art Museum, Michigan

1974
Artists Space, New York

Selected Group Exhibitions

1990
With the Grain: Contemporary Panel Painting, Whitney Museum of American Art, Fairfield County, Stamford, Connecticut

1989
American Pop Culture Today III, Laforet Museum, Harajuku, Japan

1987
Faux-Arts: Surface Illusions and Simulated Materials in Recent Art, La Jolla Museum of Contemporary Art, California

1984
American Art Since 1970. Organized by Whitney Museum of American Art, New York. Traveling exhibition

Five Painters in New York, Whitney Museum of American Art, New York

1981
35 Artists Return to Artists Space, Artists Space, New York

1980
Painting in Relief, Whitney Museum of American Art, New York

Three Dimensional Painting, Museum of Contemporary Art, Chicago

1978
American Art 1950 to Present, Whitney Museum of American Art, New York

1971
Lyrical Abstraction, Whitney Museum of American Art, New York

Awards

1991
Fellowship, John Simon Guggenheim Memorial Foundation

Fellowship, New York Foundation for the Arts

1989
Fellowship, National Endowment for the Arts; also 1982

1979
Creative Arts Public Service Program, New York

Bibliography

Adams, Brooks. "Scarred Diamonds." *Artnews*, February 1991

Sultan, Terrie. *John Torreano: Natural Models and Material Illusions.* Washington, D.C.: Corcoran Gallery of Art, 1989

Welzenbach, Michael. "Style: Magic from the Mundane." *Washington Post*, April 1989

Wolff, Theodore F. "The Art of Painting Plywood." *The Christian Science Monitor*, August 17, 1990

Ginny Ruffner is an artist whose work encompasses glass, painting, installation, and public art. She is also the immediate past president of the Glass Art Society, an international artists' organization. She lives in Seattle.

Ron Glowen is an art critic and historian based in Seattle, whose writings have appeared in numerous publications including *Artweek, Art in America,* and *American Craft.* He teaches art history at the Cornish College of the Arts in Seattle.

Kim Levin is a writer living in New York, who writes for *The Village Voice* and other publications. She is the author of *Beyond Modernism: Essays on Art from the 70s and 80s,* published by Harper and Row in 1988.